IMAGES

OF THE

OTTOMAN EMPIRE

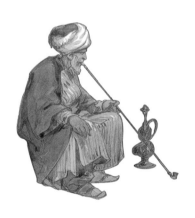

IMAGES
OF THE
OTTOMAN EMPIRE

Charles Newton

Introduction by Tim Stanley

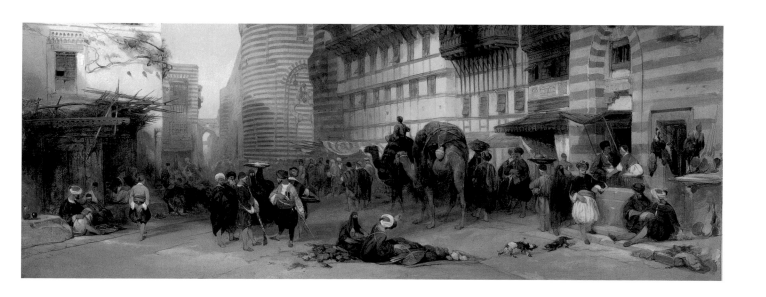

V&A Publications

To my son Harry

First published by V&A Publications, 2007
V&A Publications
Victoria and Albert Museum
South Kensington
London SW7 2RL

Distributed in North America by Harry N. Abrams, Inc., New York

Hardback edition
ISBN-13 978 1 85177 505 7
Library of Congress Control Number 2006936579

10 9 8 7 6 5 4 3 2 1
2011 2010 2009 2008 2007

Designed by Andrew Shoolbred and Greg Taylor
New V&A photography by Paul Robins, V&A Photographic Studio

Front jacket illustration: Detail from p.23. V&A: D.123-1895
Back jacket illustration: Detail from pp.42–3. V&A: SP55
Half-title illustration: Detail from pp.54–5. V&A: SD824
Title-page illustration: Detail from pp.50–51. V&A: FA176

Printed in Hong Kong

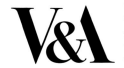

V&A Publications
Victoria and Albert Museum
South Kensington
London SW7 2RL
www.vam.ac.uk

Contents

Acknowledgements

I am grateful to my colleagues Susan Lambert and Mark Evans who recommended this project to Carolyn Sargentson and Christopher Breward of the Research Department. The generous help I received there and from my colleagues in the Word & Image Department enabled me to complete the book. My thanks go to Tim Stanley who wrote the Introduction. I have drawn heavily on the work of my former colleague Briony Llewellyn with the Searight Collection and owe her a great debt. Mary Butler, Head of V&A Publications, enthusiastically supported this project. I am grateful to my editors Ariane Bankes and Monica Woods, to my copy-editor Delia Gaze, the designer Andrew Shoolbred and to Asha Savjani. I am also grateful to Ken Jackson and many of his colleagues for photography, and to Sonia Solicari who took on many of my duties while I was in Research.

CHARLES NEWTON

Introduction

BY TIM STANLEY

Most of the images brought together in this book come from the collection of Orientalist images assembled by the Victoria and Albert Museum since its foundation in 1852. In this context, Orientalism has the double sense of the European scholarly investigation of the Orient and the production of images of the Orient by European artists. The link is that the images in question were expected to have a degree of documentary accuracy. In other words, they were seen as visual equivalents of scholarship. This required the artists to use authentic sources, and the most reliable method of achieving authenticity was for the artists to travel to the Orient themselves. As we shall see, political events at the very end of the eighteenth century facilitated the penetration of the Orient by artists, whether on official or private business. For this reason, Orientalism as art is a predominately nineteenth-century phenomenon.[1]

The balance of power

The Orient referred to is quite restricted. It consists only of the lands around the eastern Mediterranean, an area also known as the Levant. This 'land of the rising sun' (*oriens* in Latin, *levante* in Italian) was the region to the east of Italy in which Venice, Genoa and other maritime republics earned great wealth through their dominance of shipping. Their commercial dominance went largely unchallenged in the later Middle Ages, and it survived the events of 1516–17, when the Ottoman sultan Selim I united his own territories in Anatolia and the Balkans with those of the Mamluk empire in Syria and Egypt. From this date, one single power, the Ottoman Empire, held sway over the whole littoral of the eastern Mediterranean. The only other significant presence in the region was Venice, whose insular and peninsular colonies in Cyprus, Crete, the Archipelago and the Peloponnese were annexed one by one by the Ottomans over a very long period, stretching into the eighteenth century. By the beginning of the seventeenth century, however, Venetian dominance of shipping had been ended. Merchants from France, England, the Dutch Republic and other European states were now allowed to conduct trade directly with the Ottoman Empire, and they came in their own vessels.

Over the same period, a broader change occurred in the nature of European trade with the eastern Mediterranean. Until the sixteenth century, Cairo, Aleppo and other cities had been the Europeans' main source for the

luxury goods produced in the region and for those in transit from the Indian and the Pacific oceans. In the 1490s, however, the Portuguese established a direct sea route to India, round the Cape of Good Hope, and goods from South and East Asia began to enter the Mediterranean from the west. One minor token of this change is the name of the sweet orange in Turkish and Arabic. Although it originated in China, this fruit is called *portakal* or *burtuqal*, variations on the name Portugal. The Ottoman inventories also began to refer to *portakali* ceramics. When scholars came to read the inventories in the twentieth century, they first thought this word meant 'orange-coloured', but it eventually dawned on them that the Ottomans were naming imported Chinese wares after their immediate source. They were 'Portuguese' porcelains, brought from China via the Cape and Lisbon.

A second aspect of this shift in trade patterns was the nature of the locally produced goods exchanged. The Venetians had imported large quantities of finished goods from the eastern Mediterranean, especially silk and other luxury textiles. In the sixteenth and seventeenth centuries, the silks and velvets of Bursa in north-west Turkey were still being exported to Europe, but raw materials began to play a larger and larger role. Eventually, in the eighteenth century, the eastern Mediterranean emerged as an importer of finished goods from Europe, to which it exported raw materials, though the export trade continued only until Europe found a cheaper source. An example is the trade in coffee, which had become a fashionable drink in the eastern Mediterranean in the sixteenth century and in Europe in the seventeenth (see p.100; V&A: SD1307). Egypt became rich on the transit trade in coffee from the shores of the Red Sea, while the manufacture of elegant ceramic coffee pots and cups became a speciality of the kilns at Kütahya in western Turkey. In the eighteenth century, this happy situation was overturned. The Europeans began to grow coffee more cheaply on estates in the New World worked by African slaves, while the Ottoman upper classes, now dressed in silks from Lyon rather than Bursa, turned their backs on Kütahya wares and began to buy the even more elegant coffee cups produced by the new porcelain industry at Meissen in Germany.

The economic weakness of the Ottoman Empire, now dependent on the twists and turns of European demand, produced political weakness. Revenues accruing to the Ottoman government fell, and the situation was exacerbated when European merchants established direct relations with local governors, cutting out the central government altogether. By 1785, for instance, the tiny fishing village of Acre on the coast of Palestine, once the last outpost of the Crusaders, had developed dramatically into the third largest city in Syria. Its rise was funded by an export trade in raw cotton and later in grain conducted by a series of local governors and their allies, who defied the wishes and interests of their nominal overlords, the governors of Damascus, and of the central government. Acre's quasi-independence was crushed in 1832, but even today, the town's large mosque of Ahmad Pasha al-Jazzar bears witness to its moment of glory.[2]

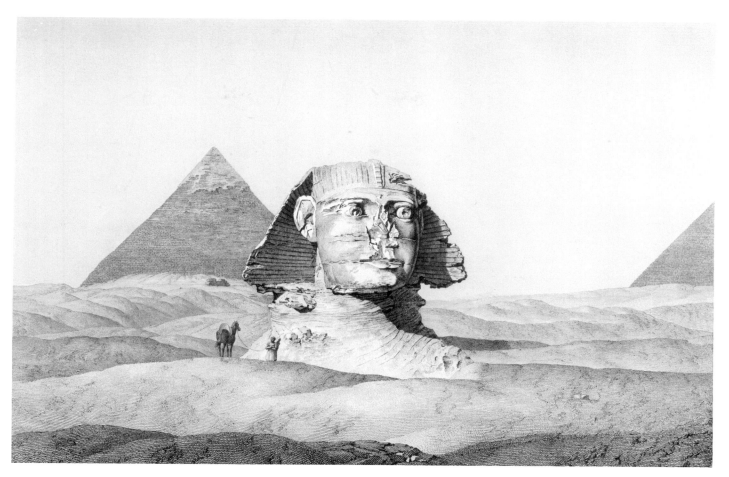

PLATE 1 'View of the Sphinx at Gizah', from the *Description de l'Egypte; ou, Recueil des observations et des recherches qui ont été faites en Egypte pendant l'expédition de l'armée française, Antiquités: Planches,* vol. V (Paris, 1822), plate 12. This is one of two views of the Sphinx after drawings made during the French occupation of Egypt in the years 1798–1801.

Ahmad Pasha also repaired and modernized Acre's Crusader fortifications, and one of his main achievements was the defence of the town in the face of a French siege in May 1799. In this, he was assisted by forces provided by the Ottoman government, which was forced to cooperate with him in a crisis, and a British naval flotilla under Sidney Smith. This action was by no means minor. Napoleon Bonaparte had invaded Egypt the previous year, but he and his army were stranded there when Nelson destroyed the French fleet at the Battle of the Nile in August. The failure before Acre prevented Bonaparte from leading his army northwards out of Egypt, and forced him to abandon his forces there when he returned to France by sea. Although the expedition to Egypt ended in military failure, Napoleon's entourage included a party of scientists and artists who used their time to prepare material for the *Description de l'Egypte,* a vast multi-volume work published between 1809 and 1822. It presented an unprecedented range of information on the ancient monuments, cities, people, handicrafts, flora, fauna and geology of Egypt (plate 1).

The French invasion of Egypt marks a major change in the activities conducted by Europeans in the eastern Mediterranean. Where merchants had once been the main actors, now there was direct military and political intervention, which brought in its wake a need to know the Orient in order to control it. Official Orientalism had been born, and it was soon joined by private forms of Orientalism, including that practised by artists.

A complicated relationship

The presence of European artists in the Ottoman Empire was nothing new. A number of Italians were employed at various times by Sultan Mehmet II, who reigned between 1451 and 1481. The physical evidence for their stay in Istanbul, the capital that Mehmet acquired by conquest in 1453, is significant. Portraits of the Sultan predominate, and they include Gentile Bellini's oil painting, now in the National Gallery in London, which is perhaps treated with more reverence than its artistic qualities merit.[3] There is also a series of bronze portrait medals, of which examples by Costanzo da Ferrara (plate 2), Bellini and Bertoldo di Giovanni are in the collection of the Victoria and Albert Museum.[4] Mehmet's direct patronage of figurative art in a western style was not the norm, however. After his death, his son Bayezit II adopted a self-consciously Islamic policy, in which work of this kind had no place. This did not prevent leading members of Ottoman society from admiring and even emulating European art, as we shall see, but in later years European artists in Istanbul worked on their own account or were employed by other foreigners, notably by ambassadors.

In 1533, for example, the Antwerp artist Pieter Coecke van Aelst visited Istanbul with the aim of selling tapestries made by the Van der Moyen factory in Brussels to the imperial court. He failed to sell any textiles, but he used the opportunity to make drawings of life in the Turkish capital, and he used these as the basis for a series of seven large woodcuts, published posthumously in 1553. One shows Bayezit II's grandson, Sultan Süleyman the Magnificent, riding to the Friday prayer; the Sultan passes the Hippodrome in Istanbul, which can be identified from the monuments that still stand there.[5] A more striking and personalized portrait of Süleyman is found in an engraving by Melchior Lorichs dated 1559.[6] In 1556 Lorichs had

PLATE 2 Portrait medal of Sultan Mehmet II, by Costanzo da Ferrara (c.1450–after 1524). The obverse shows a bust portrait of the Sultan, surrounded by a Latin inscription that reads: '[Portrait] of Sultan Mehmet Osmanoğlu, Emperor of Byzantium, 1481'. 'Osmanoğlu' is the Turkish for 'Ottoman', as in 'a member of the Ottoman dynasty'. The reverse, showing the Sultan on horseback, has the legend 'Equestrian portrait of Mehmet, Emperor of Asia and Greece, on campaign'. Beneath the horse's feet is the signature, 'The work of Costanzo'. The first version of the medal was struck about 1478–9, and this later version may have been made to commemorate Mehmet's death in 1481. V&A: A.208–1910.

gone to Istanbul to work for the Imperial ambassador, Ogier Ghiselin de Busbecq, and he stayed there for three years, producing a valuable visual record of what he saw. His largest work is a panorama of Istanbul seen from the north, across the waterway known as the Golden Horn. This was originally 12 metres long, although its owners, Leiden University Library, soon cut it up into 21 separate sections.[7]

The Ottomans did not isolate themselves from this artistic production, and some of them showed great interest in images of various kinds being produced in Europe and by European artists resident in the empire. They were able to do so partly because of the advent of printing, which had made European visual culture much more accessible in the eastern Mediterranean, just as it had in Europe. As a consequence, European elements, including categories of subject matter such as bird's-eye views of ports and cities as well as individual motifs, began to appear in Ottoman art. Until about 1700, however, the assimilation of European models into Ottoman art is not necessarily self-evident, due to differences in medium, technique and style. The Ottomans created small-scale works in water-based pigments and gold on paper, in the Islamic tradition of manuscript illustration. In topographical scenes without figures, the painter had greater leeway in the depiction of space, but where such images include human figures, they were worked out on a single plane, with very limited attempts to create an illusion of reality. This seems to have been a conscious decision to avoid the mimetic aspects of European painting, since, when European subject matter was adopted, it was recast in this Islamic mould.

A well-documented example of this relationship is the creation of the main Ottoman tradition of imperial portraiture in the late 1570s, when manuscripts started to be illustrated with portraits of the Sultans arranged in series (plate 3); they began with an entirely imaginary depiction of Osman, the local warlord from north-west Turkey who founded the Ottoman dynasty in the later thirteenth century, and ended with a portrait of the reigning monarch taken from life. The earliest examples are copies of a work by the court historian Seyyit Lokman devoted to 'The Physiognomy of Humanity as Exemplified by the Physical Characteristics of the Ottomans', which were illustrated by the leading court painter of the period, Nakkaş Osman.[8] According to Seyyit Lokman, he and Nakkaş Osman had access to a series of portraits of the Sultans that were brought from Italy through the good offices of the Grand Vizier, Sokollu Mehmet Paşa (d. 1579), and the Sultan, Murat III (ruled 1574–95). These were particularly useful for the depictions of the Sultans before Murat II (ruled 1421–51), for which they had next to no material.[9]

The series of portraits first devised by Seyyit Lokman and Nakkaş Osman continued to be updated until the nineteenth century, when V&A: SP172 (see p.20) was produced. This engraving shows the reigning sultan, Selim III (ruled 1789–1807), shortly before his deposition, and is based on the last in a series of imperial portraits produced for Selim by the court

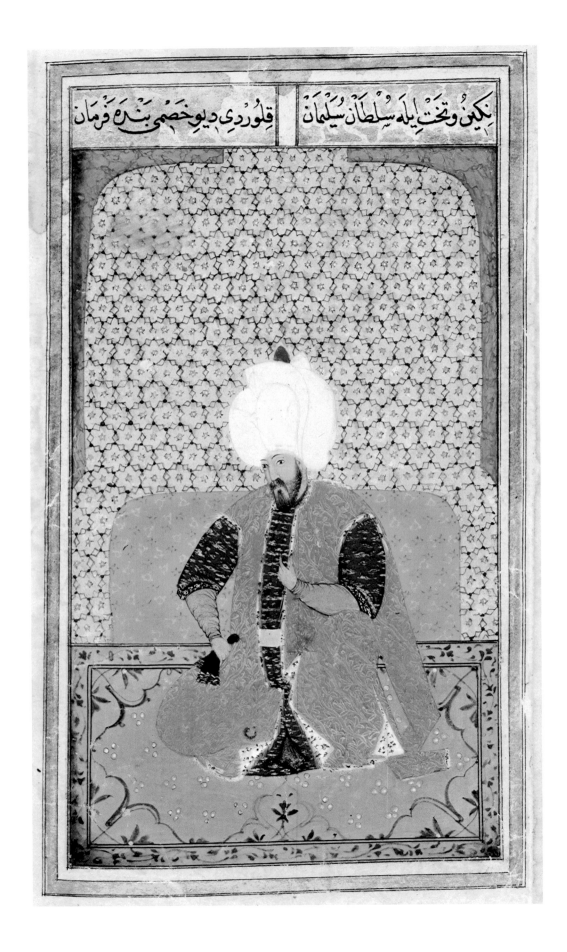

painter Konstantin Kapıdağlı.[10] It is evident from this portrait and from the other works by Konstantin and his circle illustrated here (pp.21–30) that a major change had occurred in Ottoman art by the late eighteenth century, for the artists responsible for these paintings were clearly attempting an illusion of reality in the European manner.

Given the number of European painters in Istanbul in the eighteenth century, such as those employed by the French ambassador Choiseul-Gouffier (see p.35; V&A: SD506), the obvious conclusion to reach is that this shift in style was the result of direct contact with European artists or their work. Indeed, this change has been interpreted as part of the long process of westernization to which the Ottoman Empire was subjected in the eighteenth and nineteenth centuries, and which supposedly began in the reign of Sultan Ahmed III (1703–30).[11] Such assumptions about west-ernization have now been undermined by a study of the imperial pleasure-ground at Sa'dabad near Istanbul, at the head of the Golden Horn. Sa'dabad was formerly viewed as Ahmed's attempt to rival Versailles, but the two bear no comparison in scale, layout, architectural style or any other respect. A more convincing explanation is that it was an Ottoman response to the palaces built at Isfahan by the Safavid shahs of Iran.[12] With this example before us, it is necessary to ask whether it is a coincidence that the change in Ottoman painting occurred soon after a very similar change was wrought in Safavid painting, in the reign of Shah Sulayman (1666–94).

An Iranian source for the new style would explain why it was intro-duced despite Ottoman resistance to the mimetic qualities of European painting. For, in this interpretation, the Ottomans were not abandoning an Islamic paradigm in the face of self-evident European cultural superiority; they were merely carrying out an *aggiornamento* of Ottoman painting, drawing on the Ottomans' main external source for new artistic ideas, which was the art of Muslim Iran. The shift to the new style cannot be associated with westernizing reforms of the type attempted by Selim III, the monarch portrayed on page 20; V&A: SP172, after the French occupa-tion of Egypt, since it began more than six decades earlier, in the reign of Ahmed III. Perhaps most significantly, the new style was first seen in the Ottomans' most typical form of representation, the manuscript illustration (plate 4). It cannot be a coincidence that the imperial portraits produced by Konstantin Kapıdağlı for Selim III *after* the westernizing reforms had been initiated were painted in oils, an entirely western technique.

There are good reasons for demonstrating that the introduction of the new style of Ottoman painting had nothing to do with the westernizing

PLATE 3 Portrait of Sultan Süleyman the Magnificent, from a manuscript of the *Kıyâfetü'l-insâniyye fî şemâyilü'l-osmâniyye* ('Physiognomy of Humanity as Exemplified by the Physical Characteristics of the Ottomans') by Seyyit Lokman, produced in Istanbul in 1589. This is one of a series of portraits of all the Sultans of the Ottoman dynasty up to Murat III, illustrating a text relating to the pseudo-science of physiognomy. British Library, MS. Add. 7880, folio 53b.

reform movements of the late eighteenth and nineteenth centuries. If every sign of western influence on Ottoman society and culture is associated with desperate attempts at reform, it confirms the outdated concept that after the golden age of the mid-sixteenth century, Ottoman society went into permanent decline, from which it could be rescued only by emulation of the West. This idea, in turn, fits very well with a teleological interpretation of the 'rise of the West'. As has been shown above, the Ottoman Empire was certainly caught in a downward spiral, but this was a lengthy and complex process, and it began to enter the critical stage that stimulated the Westernizing reforms only in the second half of the eighteenth century.

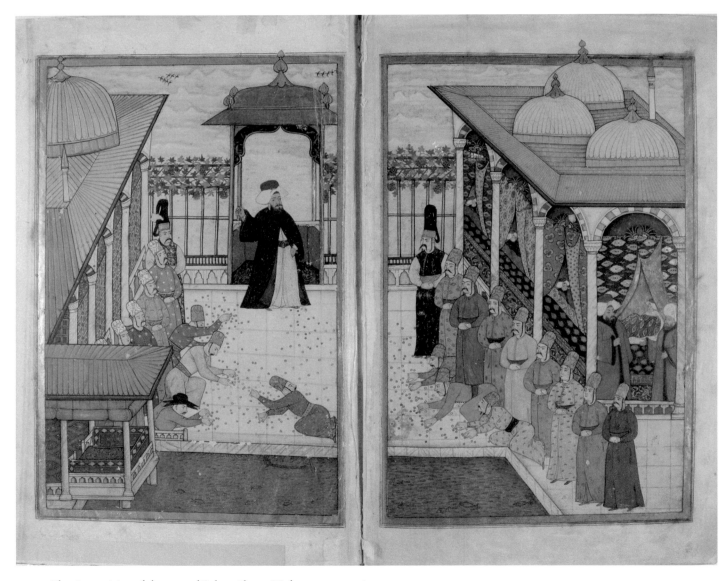

PLATE 4 The circumcision of the sons of Sultan Ahmet III, from a manuscript of the *Surname* ('Book of Festivities') by Vehbi, produced in Istanbul in 1720 or soon after. On a terrace in the Topkapı Palace, the sultan scatters coins before members of his household, while the three boys lie in the beds to the right. Topkapı Palace Museum Library, Istanbul, MS. A. 3593, folios 174b and 175a.

The challenge of Orientalism

The artistic exchanges between the Ottomans and the rest of Europe described above are one aspect of the peaceful interaction that took place between them. But, as the illustration on page 90; V&A: E.912–2003, for example, suggests, war also played an important role in this relationship, as did the belittling of the Ottomans for propaganda purposes. This woodcut was part of an attempt to play up the defeat of the Ottoman fleet at the Battle of Lepanto, which took place in the Gulf of Corinth in 1571, even though, as Charles Newton notes below, the defeat did little to hinder the Ottomans' effectiveness as a naval power. Europeans also needed reliable intelligence on the Ottomans, both as enemies and as trading partners, and a good deal of effort went into compiling books that gave an account of how the Ottoman Empire worked. An early example remarkable for its thoroughness is the *Relazione* of Jacopo de Promontorio, compiled about 1475. This remained in manuscript until the twentieth century, but other works went through many editions. A less original example in English is the *Generall Historie of the Turkes* by Richard Knolles, which was first published in 1603 and subsequently reissued in many different forms. This type of publication was still going strong when Napoleon arrived in Egypt, as is shown by the magnificent *Tableau général de l'Empire othoman* dedicated to the King of Sweden by Ignatius Mouradgea d'Ohsson (1740–1807; plate 5). In many ways, however, the *Description de l'Egypte* outclassed them all, although the scholarly endeavours triggered by an increased familiarity with Egypt made this great work out of date even as it was published.

After 1800, all these trends were subsumed in Orientalism. This vast output of scholarly and artistic material sometimes shares the hostile motives, the condescension and even the sexual prurience of some of the earlier examples, and for this reason the whole body of work has come under suspicion since the publication of Edward Said's *Orientalism* in 1978. Said rightly saw the negative role of some Orientalist output in dehumanizing the inhabitants of the eastern Mediterranean and justifying European intervention there, a process that is very much alive today. Yet Orientalism was very diverse. It was created by French and British intervention in the eastern Mediterranean, but this official action also provided the framework for private ventures of new types. An important factor was that more and more Europeans, including many artists, felt that the eastern Mediterranean was secure enough to travel there. Another was the new, faster and cheaper means of transport that facilitated their arrival in the region, and their journeys within it.[13] In the case of artists, a third factor was the development of new markets for images of the eastern Mediterranean that were seen as having documentary value.

The images presented in this book are mainly examples of these outsiders' views of the Ottoman Empire. When the artists arrived in the eastern Mediterranean, they carried with them a variety of assumptions

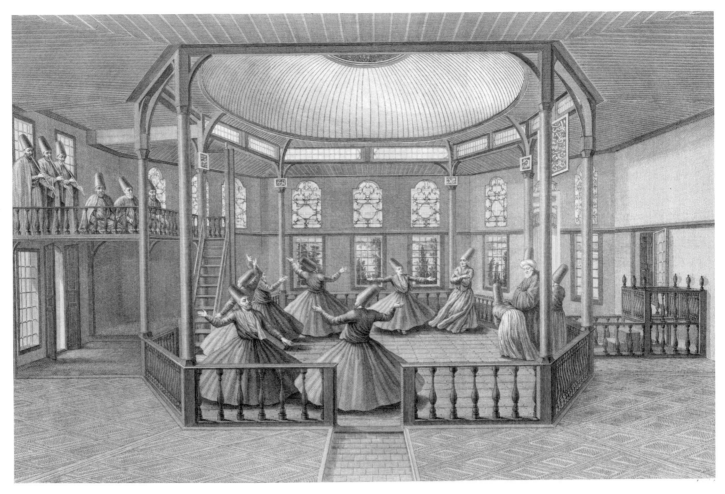

about the region and its inhabitants. Some were abandoned when the visitors were faced with the real thing. Other assumptions survived, and some may even have been reinforced, by the artists' experience of the places they depicted. It is therefore not possible to take the works reproduced here as an unmediated representation of reality. Yet in many cases, these images made by foreign artists provide some of the best visual information available on a particular aspect of the Ottoman lands in the nineteenth century, and it is therefore worth the effort to understand why they were made. Charles Newton has certainly taken a step in the right direction by considering the works he has selected from the point of view of the professional background of the artists responsible for them and the pattern of patronage within which they worked. In some instances his selection exceeds the boundaries of time and place set out above (e.g. pp.88–9; V&A: SD382, SD296, SD406, E.912-2003, SD1237, SP113), but the core of this book

consists of nineteenth-century images of the Ottoman Empire belonging to the Victoria and Albert Museum.

These holdings of the V&A are simply the world's largest collection of watercolours, prints and drawings of Ottoman subjects by European artists. They were given their distinctive shape by the acquisition in 1985 of the collection of Rodney Searight, a former director of Shell International Petroleum Company, who worked in Egypt and elsewhere in the Middle East for many years. Searight began collecting in the early 1960s, when there was little interest in Orientalism, and his enthusiasm and researches on the subject have helped to focus attention on what is now a relatively popular field of study. The V&A acquired his collection with the aid of Shell International, the National Art Collections Fund, the National Heritage Memorial Fund, Gianni Versace and the Friends of the V&A. Rodney Searight's collection was combined with the already substantial resources found in the Museum's Print Room and in the National Art Library, and this book can represent only a tiny fraction of the images available.

NOTES

1 See, for example, Kenneth Bendiner, 'Orientalism', in *The Dictionary of Art*, edited by Jane Turner (London, 1996), vol.XXIII, pp.502–5.

2 Thomas Philipp, *Acre: The Rise and Fall of a Palestinian City, 1730–1831* (New York, 2001).

3 See most recently *Bellini and the East*, exhibition catalogue by Caroline Campbell and Alan Chong (National Gallery, London, and Isabella Stewart Gardiner Museum, Boston, 2006), no.23.

4 Ibid., nos 17, 20 and 21.

5 Stéphane Yerasimos, in *Soliman le Magnifique*, exhibition catalogue (Galleries nationales du Grand Palais, Paris, 1990), no.311; Jürg Meyer zur Capellen in *The Sultan's Portrait: Picturing the House of Osman*, exhibition catalogue (Topkapı Palace Museum, Istanbul, 2000), no.20.

6 Ibid., no.22.

7 Yerasimos, *Soliman le Magnifique*, no.315; Erik Fischer, 'Melchior Lorck: A Dane as Imperial Draughtsman in Constantinople in the 1550s', in *The Arabian Journey: Danish Connections with the Islamic World over a Thousand Years*, exhibition catalogue (Prehistoric Museum Moesgård, Århus, 1996), pp.31–43.

8 The Victoria and Albert Museum has a copy of this work (V&A: 682–1876), purchased in Iran. At one point the faces were obliterated and then repainted. The obliteration may have been an anti-Ottoman gesture rather than an act motivated by religious scruples.

9 Part of the Italian series, which has been attributed to Paolo Veronese or his workshop, survives in the Topkapı Palace collections. The story of their procurement is known from Venetian sources; see Julian Raby, 'From Europe to Istanbul', in *The Sultan's Portrait*, pp.150–63.

10 For the original, see *The Sultan's Portrait*, no.138.27.

11 See, for example, Fatma Müge Göçek, *East Encounters West: France and the Ottoman Empire in the Eighteenth Century* (New York and Oxford, 1987).

12 Can Erimtan, 'The Case of Saadabad: Westernization or Revivalism?', in *Art turc/Turkish Art: Proceedings of the Tenth International Congress of Turkish Art, Geneva, 17–23 September 1995* (Geneva, 1995), pp.287–90. For another example along the same lines, see Tim Stanley, 'The Baroque and After', in Manijeh Bayani and Tim Stanley, *The Decorated Word: Qur'ans of the 17th to 19th Centuries*, The Nasser D. Khalili Collection of Islamic Art, vol.IV, part two, forthcoming.

13 One man who took advantage of these new opportunities was the architect, designer and art theorist Owen Jones (1809–1874), see p.72. Jones travelled in the Mediterranean in the early 1830s, and his experience there eventually led to his having a profound effect on the collecting policy of the future Victoria and Albert Museum, ensuring that it acquired one of the world's greatest collections of Islamic art of the Middle East; see Tim Stanley, 'Islamic Art at the V&A', in *The Making of the Jameel Gallery of Islamic Art at the Victoria and Albert Museum*, edited by Rosemary Crill and Tim Stanley, forthcoming.

Ambassadors

On occasion, the Sultan himself would commission illustrations of his empire to give as presents or propaganda to ambassadors. Although theoretically an ambassador was the impersonal servant of a sovereign state, representing its aspirations and exerting its influence on political relations as a mere representative, he was nevertheless a human being with personal tastes and interests. Since the Ottoman Empire appeared so visually different from their own countries, ambassadors often desired to bring back pictures that captured more precisely the idiosyncratic nature of the culture that they had experienced directly. The privileged position of the officials attached to courts and legations, usually wealthy men, meant that they could commission artists for the recording of their own tour of duty. Their status gave them opportunities denied to most others; for example, they could obtain a document of permission (*firman*) from the Sultan and send their artists to places not normally available to the ordinary trader or traveller. Thus Stratford Canning was able to see the interior of the imperial mosque of Aya Sofya, send his Greek artist to draw it, and could arrange for his visitors and friends (who included Lord Byron) to visit it. One of his predecessors, Sir Robert Ainslie, was so taken with Turkish culture that he dressed and behaved as a Turk himself. In his enthusiasm Sir Robert commissioned Luigi Mayer to make all kinds of pictures of the empire. Luigi, like most others in similar employment, usually had to paint exactly what His Excellency required. The subjects included the Turkish court, the country, its peoples, antiquities, manners and customs, and the official's own role. Ainslie's wide interests, however, enabled Mayer to make a large series of picturesque and sometimes unique images of the empire, which are still eagerly collected.

Some ambassadors, usually the unsuccessful ones like Edward Wortley Montagu, did not seem to bother about recording the visual nature of the country in which they resided. They remained content with only formulaic portraits of themselves being presented to the Sultan, by fashionable resident artists such as Jean-Baptiste Vanmour, the French ambassador's artist. However, even incompetent Edward had brought with him Lady Mary Wortley Montagu, and inadvertently gave her the opportunity to describe intimately the Turks and their culture (perhaps still the best description by a British writer) and to introduce inoculation against smallpox to Britain.

Thus ambassadors often had the status, opportunity, wealth and interests to commission some of the most valuable representations of the Ottoman Empire, and it is fortunate that so many did. The nature of their employment compelled them to study and even spy on the country in which they resided; yet the most enlightened provided visual information that has long outlived their residence there.

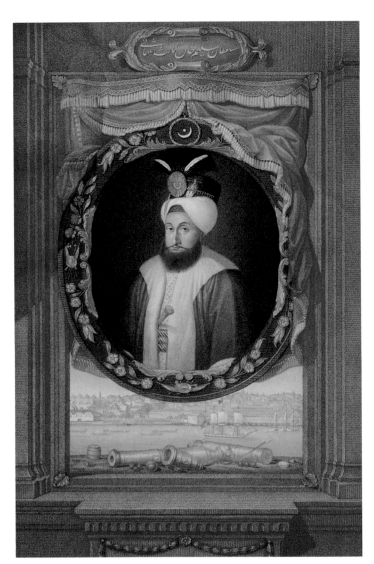

Sultan Selim III

1808
After Konstantin Kapıdağlı
Stipple engraving printed in black, brown, red and blue
V&A: SP172

Sultan Selim III (ruled 1789–1807) was a skilled calligrapher and a musician, and was interested in western culture, particularly painting. This splendid print shows how he wished to be represented, since it reproduces an oil portrait painted for him by one of his subjects, the Greek court artist Konstantin Kapıdağlı. The Sultan rarely had leisure for these pursuits, since he tried to retrieve territory seized by France, Venice, Austria and Russia, and to suppress rebellions within his own dominions. He had to alternate diplomacy with aggression throughout bewildering changes of alliance caused by the upheaval of the Napoleonic Wars. Selim set up permanent embassies in Prussia, France and Austria.

In this image, Selim's recently modernized naval dockyard at Kasımpağa in Istanbul is shown in the background, and newly cast cannon and mortars are lying in the foreground. In 1796 the French, for the moment allies, had sent the Sultan artillery, munitions, engineers and artillerymen, as part of Selim's scheme to improve Ottoman military efficiency. His attempts, however, to modernize the army along Napoleonic lines and to reform or replace the Janissary regiments resulted in his deposition and death at their hands. These notoriously unruly soldiers resented his break with tradition and his attempts to set up the *nizam-i-cedid*, the 'new order'.

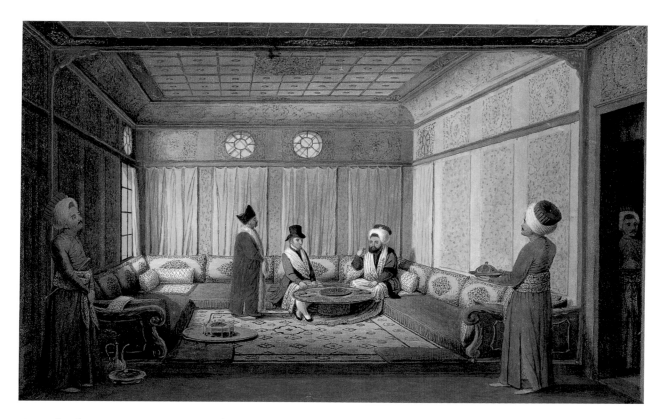

Stratford Canning Dining with an Ottoman Official

c.1809
Anonymous artist in the circle of Konstantin Kapıdağlı
Watercolour and body colour
V&A: D.124–1895

Stratford Canning (1786–1880, later 1st Viscount Stratford de Redcliffe) began his long diplomatic career in Turkey as First Secretary to Robert Adair on his mission to Istanbul in 1808. On his arrival Canning soon arranged to see officially (and unofficially) all manner of Ottoman institutions, buildings and customs. What made his curiosity really valuable is that he hired a local artist to make a large series of views and studies of what he had seen. Canning mentions an occasion when he met and dined with the *Kaymakam* or Governor of Istanbul, and this is probably the illustration of it. Careful examination of the image shows the fashionably dressed Briton (still with his hat on) dining in a sumptuously furnished room with a richly dressed Ottoman official. They eat together at a low table, each draped with an embroidered shawl like a kind of large napkin to protect their clothes. Next to the table, clad in distinctive fur-trimmed robes and hat, stands the *terjuman* or interpreter.

The identity of the artist is unknown, although Turkish scholars believe that he was part of the studio or circle of Konstantin Kapıdağlı. His style combines the dense and brilliant watercolour and body colour used by Ottoman artists with European conventions of representation and perspective. As a young man in 1810, the artist and future neo-classical architect Charles Cockerell went to Istanbul, stayed at the embassy and even met Byron. With an interpreter, he met and discussed painting technique with this Greek artist, whom, frustratingly, he did not name in his letters, although he did copy some of his drawings. It seems evident that the artist had not studied in Europe, but certainly had seen European paintings, prints and drawings. Sultan Selim had encouraged the study of European art, and this artist's work was the result. Cockerell's copies of the Greek's architectural views are now in the British Museum, London. The V&A finally acquired the original set of drawings from Canning's daughter Charlotte in 1895.

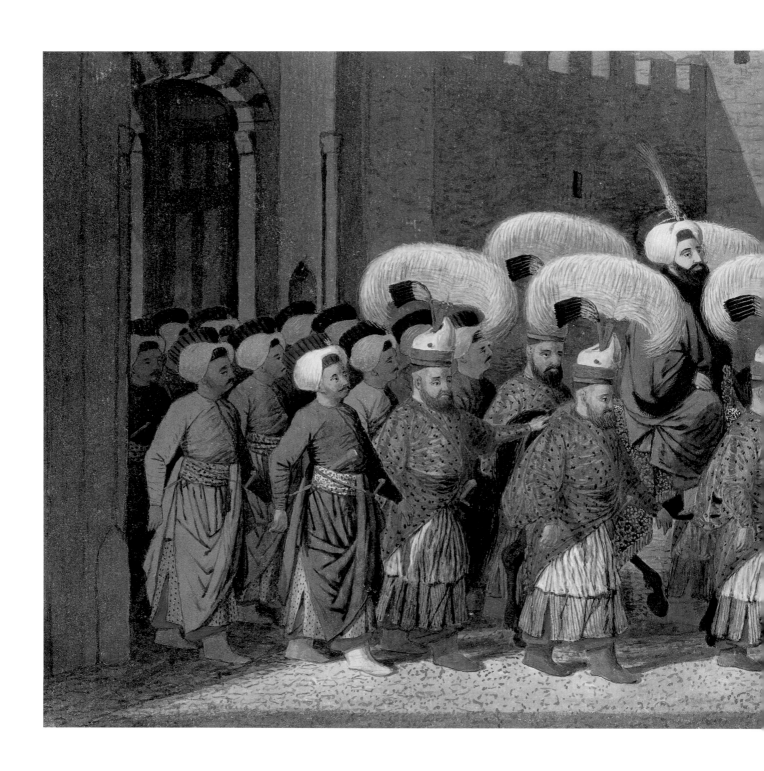

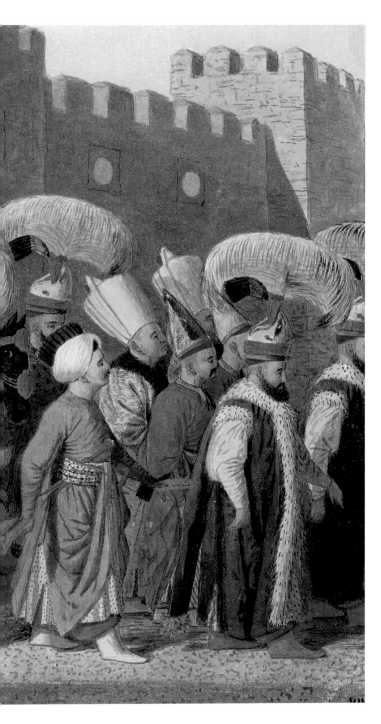

Sultan Mahmud II Going to Friday Prayers

*c.*1809
Anonymous artist in the circle of Konstantin Kapıdağlı
Watercolour and body colour
V&A: D.123–1895

Every Friday the Sultan would ride out in procession through the streets of Istanbul, accompanied by his escort of guards on foot. He attended Friday prayers at the Imperial Mosque, the day that the *hutbe* or sermon was preached. Here Sultan Mahmud II (b. 1784, ruled 1808–39) is seen emerging from the gate of his palace, Topkapı Sarayı, nearly hidden by his guards (*Solak*) with their elaborate head-dresses, other officers of the guards and officials.

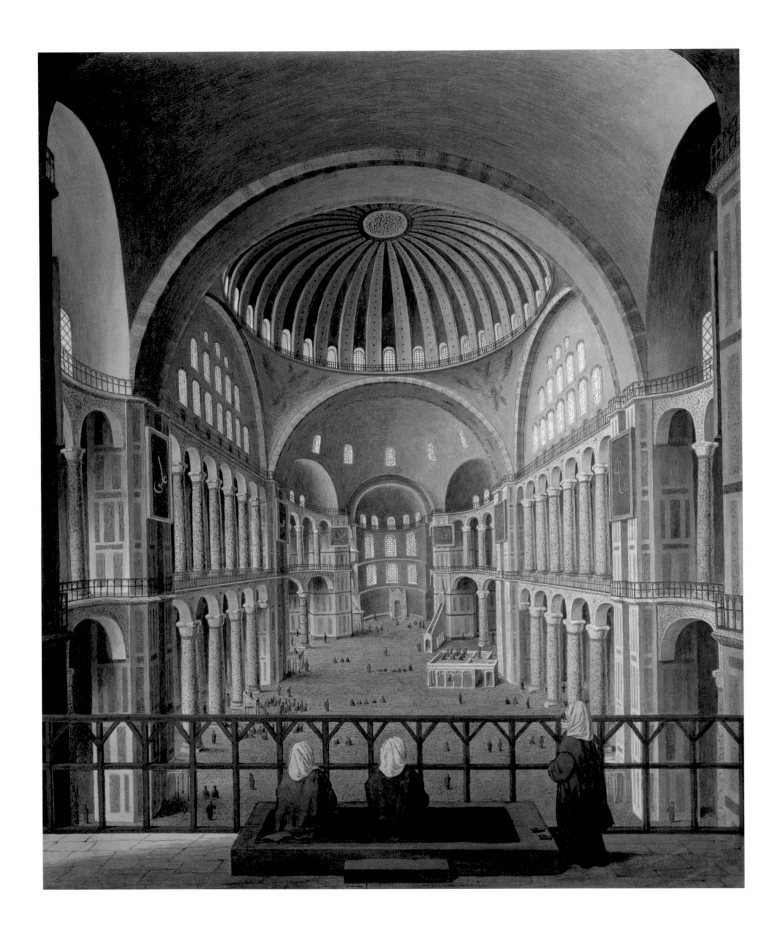

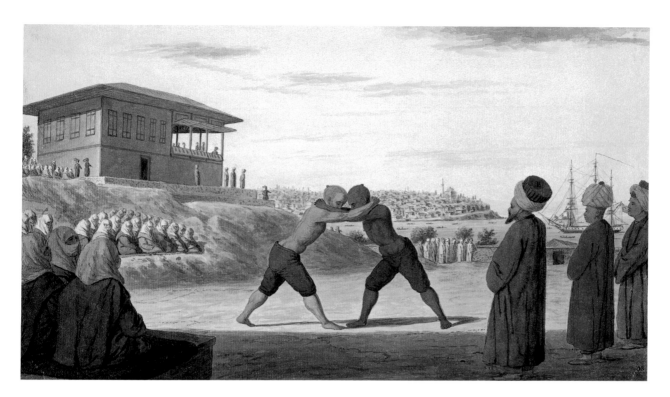

Aya Sofya

*c.*1809
Anonymous artist in the circle of Konstantin Kapıdağlı
Watercolour and body colour
V&A: D.146–1895

Many travellers who were staying at the British
Embassy tried to arrange a visit to the former
church of Hagia Sophia ('Holy Wisdom'), or
Aya Sofya as the Turks call it (see p.74). This
magnificent ancient structure was converted
into a mosque after the fall of Constantinople in
1453. It was necessary at the beginning of the
nineteenth century to obtain a *firman* or permis-
sion from the Sultan for non-Muslims to visit
the building, and they were not often granted.
Usually, the Embassy would make the arrange-
ments and visitors would join the party if they
could. This is a view from the gallery where
women normally sat, looking down towards the
spot where the altar once stood. In Byzantine
times there was also an area in the galleries
reserved for women. This is a particularly good
and early view of the structure before the
thorough restoration by the Fossati brothers,
which the Sultan commissioned in the 1850s.

A Greased Wrestling Match in the Gardens of the Palace

*c.*1809
Anonymous artist in the circle of Konstantin Kapıdağlı
Watercolour and body colour
V&A: D.115–1895

As well as drawing the mosques and details of
architecture for Canning, the Greek artist also
illustrated less cultured images and events. This
shows a *güreş* or greased wrestling match (still
a popular sport in modern Turkey), the young
men competing in leather shorts, their bodies
shiny and slippery with oil. The veiled women
forming the audience are seated within the gar-
dens of the Sultan's palace at Topkapı while
the referee presides. In the background is the
Sultan's *köşk*, a kind of grand summerhouse
whose name gives us the English word 'kiosk'.
It is not clear whether Canning himself attended
the event, or quite who the women were who
wanted to see it.

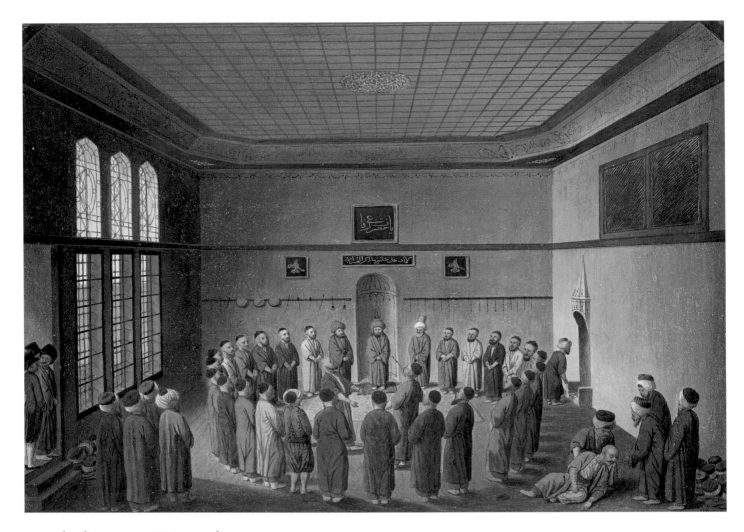

Stratford Canning Visiting the Convent of the Rufai Dervishes

c.1809
Anonymous artist in the circle of Konstantin Kapıdağlı
Watercolour and body colour
V&A: D.140–1895

There were several kinds of dervish beside the famous Mevlevis, or Whirling Dervishes, to be seen in Istanbul. Even more spectacular in the eyes of western visitors were the Rufai. They gathered in their *tekke* or convent, and after chanting the Name of God for hours would perform miraculous feats of endurance. Here they are shown in the act of swallowing red-hot skewers, oblivious to the presence of Stratford Canning at the door.

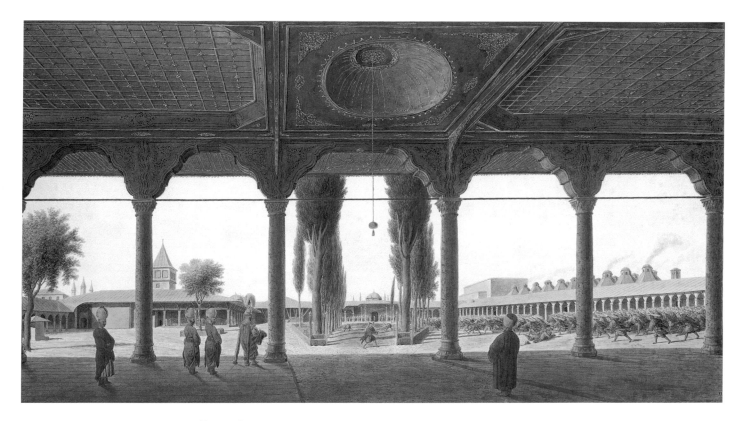

Janissaries Running To Collect Their Pay in Topkapı Sarayı

c.1809
Anonymous artist in the circle of Konstantin Kapıdağlı
Watercolour and body colour
V&A: D.143–1895

The Janissaries (*Yeni Çeri*, the 'new troops') were from the time of their institution in the later fourteenth century the imperial guard. There was a complex system of enforced conscription called the *devşirme* or 'collection'. Christian communities had to provide a certain number of young recruits, who were taken away and re-educated as Muslims and soldiers. If they showed promise and intelligence, they could become part of the imperial household as pages in Topkapı Sarayı, and perhaps rise to high office. Most remained as soldiers, carefully graded in their duties according to their intelligence. Since they had been forcibly taken from their families, they were in theory slaves of the Sultan (Muslims could not be enslaved), and owed their allegiance only to him. In the early days of the empire they were a truly formidable force, but as the Sultans ceased to lead their troops in battle, and the system grew corrupt, mutinies occurred frequently. By the beginning of the nineteenth century, the situation had deteriorated so badly that the

Janissaries had even deposed and killed the enlightened Selim III, who had tried to introduce reforms. Sultan Mahmud, who had very narrowly escaped death at their hands, was forced to wait until he had slowly assembled and trained a loyal force, before finally engineering another mutiny in 1826, and this time exterminating the Janissaries with artillery.

At the moment that these images were being made, the traditional costumes of the soldiers and officials were frozen in time. The Sultans had wished to reform along European lines, but at first were unable to prevail against centuries of custom and splendour of dress. Until the Janissaries' opposition was crushed, the period of rapid reform in the 1830s and '40s (the *Tanzimat*) could not even be approached.

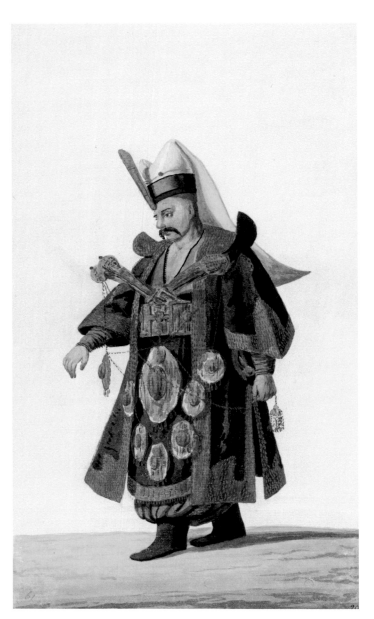

The Serasker
[Commander-in-Chief]

*c.*1809
Anonymous artist in the circle of Konstantin Kapıdağlı
Watercolour and body colour
V&A: D.51–1895

The elaborate outfits of court officials and
soldiers were rich and impressive, and meant to
be. Chinese influence on Ottoman art and design
remained strong until the nineteenth century,
and the parade uniform of the *Serasker* shows
some of this influence. The identification of
particular costumes is sometimes difficult now,
because there were, as in many armies, different
uniforms for parade, battle and everyday wear. A
further Ottoman complication was that rank was
apparently also indicated by awards of different
kinds of headgear and turban, while the rest of
the costume remained the same.

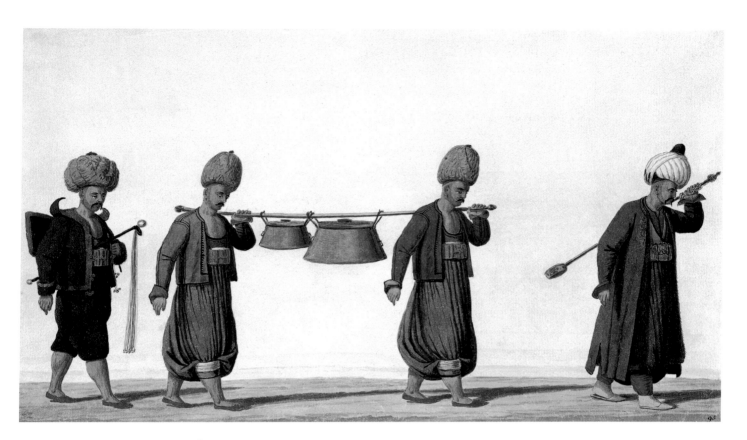

Two Janissaries Carrying the Soup Cauldron, Another Carrying the Giant Regimental Spoon

*c.*1809
Anonymous artist in the circle of Konstantin Kapıdağlı
Watercolour and body colour
V&A: D.117–1895

Soup, the mainstay of soldiers' rations, had great symbolic significance for the Janissaries. One legend claims that the order of Janissaries had been formed in the fourteenth century with the blessing of the dervish Hacı Bektaş, and so the soup on which they dined together had an almost sacramental element. It was prepared in special copper cauldrons (*kazan*). If the worst happened, the soldiers would upturn their cauldrons and beat on them like drums as a signal of mutiny. The giant regimental spoon was equivalent to a standard in battle, and to lose it to the enemy was a sign of disgrace. Each Janissary had his personal spoon (*kaşık*), which was carried in a special spoon container (*kaşıklık*) on the front of his ceremonial headdress.

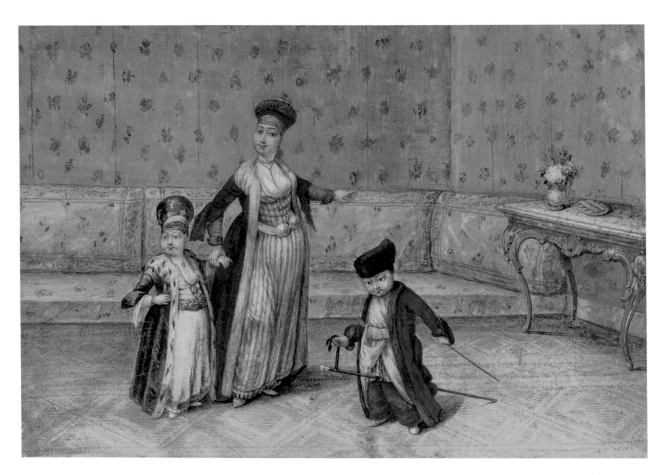

The Family of a Court Interpreter

c.1750
Anonymous artist
Gouache and watercolour on vellum
V&A: SD1312

This portrait group of a mother with her two children is an intriguing painting, but no information is now available apart from the contents of the image itself. Judging by the female dresses, it is an Ottoman subject and the family might be wealthy Greeks, *Feneriotes*, who lived in the Fener district of Istanbul. Others have suggested instead that the rather bulbous turbans worn by the mother and daughter might be Armenian. So few paintings of this period and type of subject survive that it is difficult to make comparisons. The painter's style is fairly similar to that of Raphael the Armenian, Court Painter to the sultans Mahmud I, Osman II and Mustafa III, and our painter was possibly a member of his circle.

Closer inspection of the picture reveals more details of their lives. The walls of the room are lined with what is probably a French silk and the table is a fashionable Rococo marble-topped side table, imported from France. The sofa is Ottoman in design, but the silk covering was probably imported as well. Children of the wealthy were often dressed in miniature versions of their parents' outfits. The boy is wearing an outfit normally worn by a *terjuman*, a dragoman or interpreter at the court of the Sultan, with a very distinctive fur-trimmed hat and robes. Since this was a kind of uniform at court, there is no clue as to which community his father the interpreter actually belonged. He must have been a rich man to afford the expensive imports of French furnishings. This image reminds the viewer that trade and the exchange of fashionable ideas in design between the Ottomans and France and Britain went on virtually uninterrupted from the sixteenth century until 1914 and the final days of the empire.

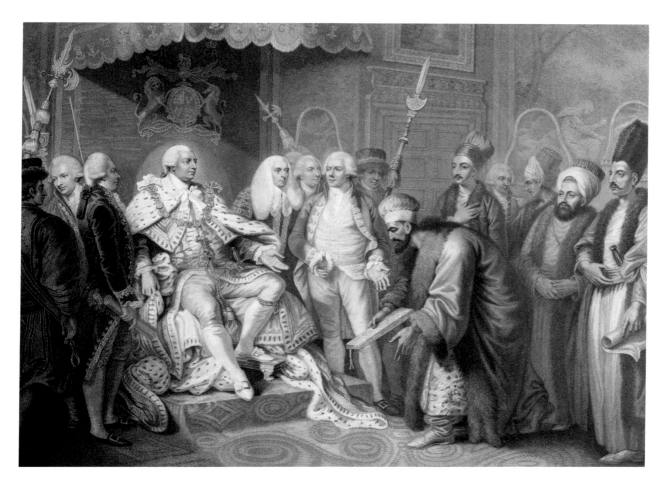

*His Majesty and the Officers of State
Receiving the Turkish Ambassador
and Suite*

Published 1797
After Mather Brown (1761–1831)
Stipple, line engraving and etching
V&A: SP127

Sultan Selim III set up permanent embassies in
Prussia, France and Austria, and sent out the
first resident Turkish ambassador to the Court
of St James, Yusuf Ağa Efendi. He arrived in
London in December 1793. He is shown here
presenting his credentials to George III.
Significantly, the print, after a large painting
by Brown, is dedicated to His Grace the Duke of
Leeds, Governor of the United Turkey Company.
The trade between Turkey and Britain continued
virtually uninterrupted for approximately
340 years, from the foundation of the Turkey

Company in 1581 to the outbreak of the First
World War in 1914.

Mather Brown was an American miniaturist
who settled in London. In 1781 he had become
a pupil of his fellow American Benjamin West,
historical painter to George III. The network of
patronage did not end there, since Brown adver-
tises himself on this print as 'Historical Painter
to their R.H. The Duke & Duchess of York', and
Daniel Orme, the engraver, proudly reveals that
he is 'Historical Engraver to his Majesty & his
R.H. the Prince of Wales'.

View of Grand Cairo from the Summit of the Great Pyramid of Giza

*c.*1800
Luigi Mayer FSA (*c.*1750–1803)
Watercolour and gouache
V&A: SD642

This remarkable view from the top of the Great Pyramid is a dramatic watercolour typical of Luigi Mayer's work in Egypt. Mayer trained in Rome, yet very little is known about his origins or personality, or even if he was German, Swiss or Italian in origin. After painting landscapes for the King of Naples, he found employment about 1786 with the British ambassador to Istanbul, Sir Robert Ainslie, as well as journeying with other British travellers. For a time he became the ambassador's painter at a salary of 50 guineas a year, and had to paint swiftly whatever caught His Lordship's fancy when travelling. This did not seem to quell his painterly vigour and enthusiasm, so that his lively watercolours of the antiquities, architecture, landscapes, manners and customs of the inhabitants of Egypt, Syria, Turkey, Greece, Romania and even Suffolk are still eagerly collected. Mayer went to England with Sir Robert in 1794, and between 1801 and 1810 aquatints after his watercolours were published in several volumes sponsored by Ainslie. Luigi's paintings necessarily reflect his employer's attitudes to the peoples he visited. According to the *Dictionary of National Biography*, however, Ainslie was alleged to be 'strongly attached to the manner of the people . . . in his house, his garden, and his table he assumed the style and fashion of a Musselman [Muslim] of rank; in fine, he lived *en Turk*, and pleased the natives so much by this seeming policy . . . that he became more popular than any of the Christian ministers' (*St James's Chronicle*, 9 December 1790).

Luigi died in 1803, survived by his widow Clara, daughter of Mr Barthold, an interpreter employed by Sir Robert. Clara continued to live in London, painting and selling landscapes, publishing her work and assisting in the publication of her late husband's paintings.

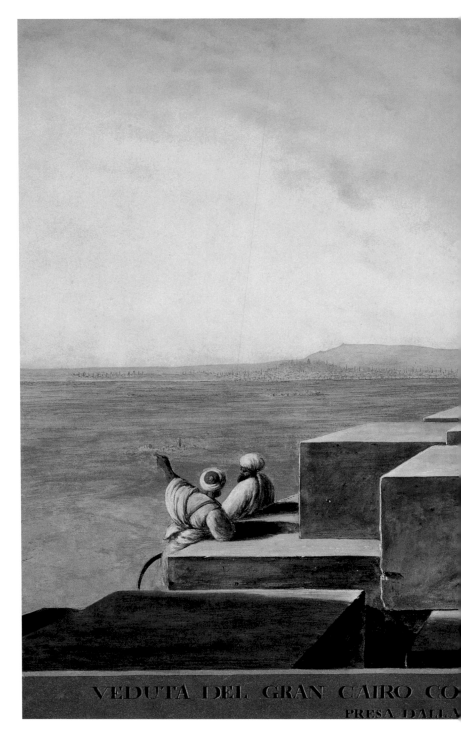

VEDUTA DEL GRAN CAIRO CO
PRESA DALLA

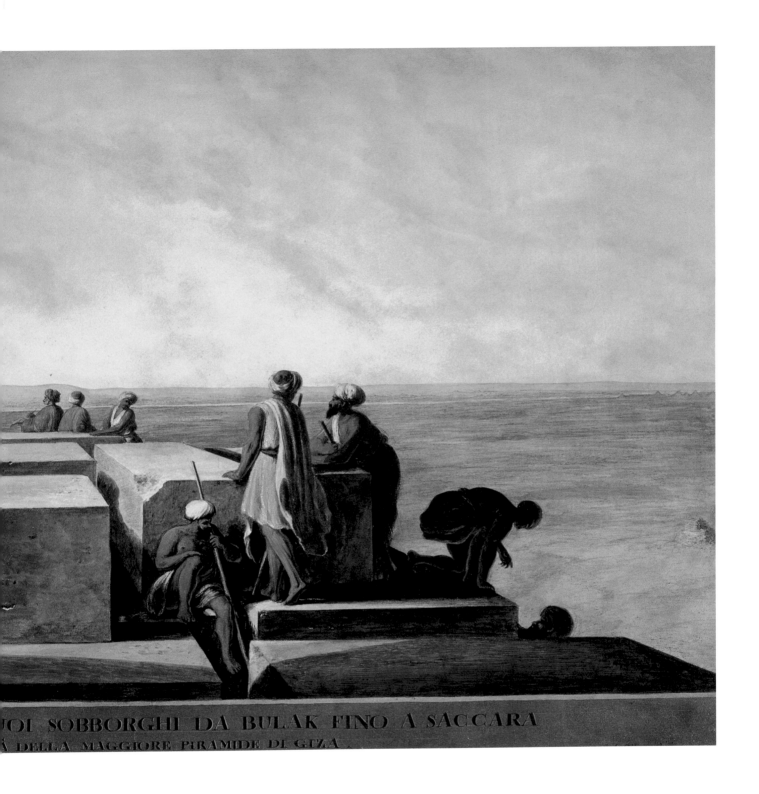

IOI SOBBORGHI DA BULAK FINO A SACCARA
À DELLA MAGGIORE PIRAMIDE DI GIZA

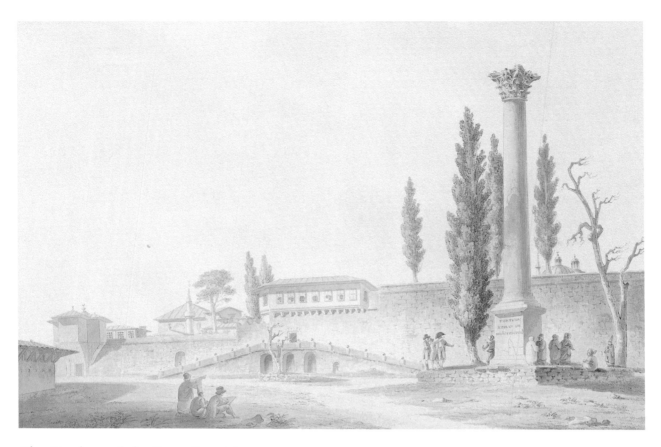

The Gardens of the Seraglio with European Visitors Inspecting the Column of the Goths, Istanbul

*c.*1810
Michel-François Préaulx (active 1787–1827)
Pen and ink and watercolour
V&A: SD819

It was common for artists, while working for patrons interested in studying, measuring and recording ancient monuments, to include little portraits of themselves at work. Here, while Préaulx sketches in the foreground, accompanied by two curious Turkish onlookers, his patron or patrons are examining the Goth's Column, a granite monolith 15 metres high, surmounted by a Corinthian capital. In the background are the wall and gateways to the palace grounds. This column (probably recycled from a temple) is alleged to date from the time of Constantine the Great, perhaps just after CE 332. It is one of the oldest but least-known monuments in Istanbul and commemorates a victory over the Goths, as its partly visible inscription states. It stands in what is now Gülhane Park, among the trees, next to a tea garden and a zoo, between the palace of Topkapı and Saray Burnu (Seraglio Point).

Almost nothing is known about Préaulx's early life, except that he possibly studied in Rome. He arrived in Istanbul in 1796, with a group of fellow French architects, engineers, cannon founders and artists who had been commissioned to supply military and naval installations for the Ottoman forces. The French had been invited by Sultan Selim III, desperate to improve the defences of his empire, which was threatened by hostile nations, especially Russia, and by internal rebellions. Somehow Préaulx survived the difficulty of Napoleon's France subsequently changing from an ally to an enemy of the Ottomans, and he continued to execute topographical drawings for many British and French visitors, including Lord Elgin, British ambassador in Istanbul from 1799 to 1803.

Albanian Soldier

1778
Jean-Baptiste Hilair (or Hilaire) (1753–1822)
Pen and ink, and watercolour, over pencil
V&A: SD506

Hilair, a pupil of Jean-Baptiste Le Prince, was
one of several artists employed by the Comte
de Choiseul-Gouffier, the French ambassador in
Istanbul between 1784 and 1792. He had accom-
panied the Comte on an earlier visit to Greece
and Turkey in the years 1776–9, and contributed
numerous illustrations to his publication *Voyage
pittoresque de la Grèce* (Paris, 1782).

The Albanians were popularly supposed to be
some of the fiercest warriors in the Ottoman
dominions, and were frequently depicted by
travellers, who could easily recognize their
distinctive costume. Hilair was a meticulous
draughtsman, using the traditional technique of
fine pen-and-ink drawing, coloured with careful
washes of watercolour. Here he has shown in
fine detail such things as the splendid coat, the
tasselled cap, the embroidered bag, the patterned
leggings and the enormously long *çubuk,* or
cornel-wood tobacco pipe. However, Hilair
reminds his audience of the martial nature of
this Albanian by indicating the partly visible
barrel of his long musket, although the rear
view does not permit illustration of the sword,
dagger and pistols that were normally carried
in the belt or sash.

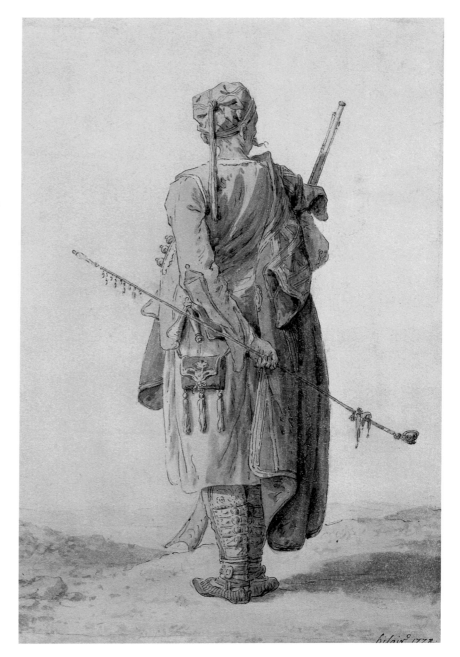

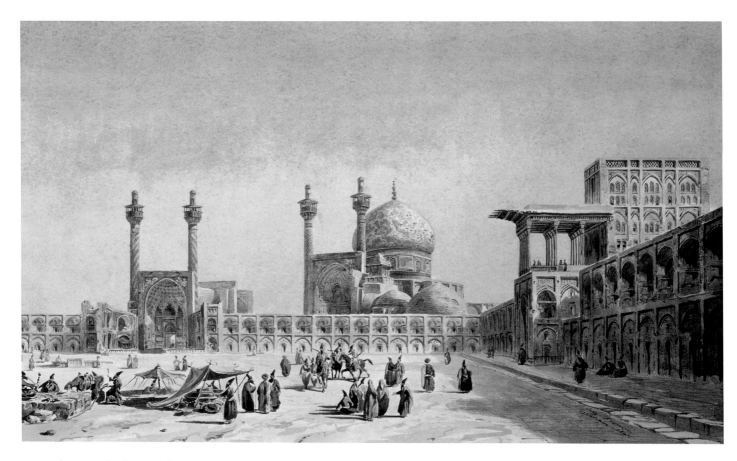

Maydan-i-Shah, Ispahan

1841
Eugène-Napoléon Flandin (1809–1876)
Watercolour over pencil
V&A: SD382

The wide expanse of the Maydan was created as a polo ground by Shah Abbas soon after he moved his capital to Ispahan (Isfahan) in the early 1600s. On the far side is the Masjid-i-Shah, the Mosque of the Shah. The alignment, at an angle to the entrance portal, was to ensure the correct orientation of the building towards Mecca. On the right is the Ali Qapu, the gatehouse of the palace complex, with its enormous wooden loggia projecting over the square. From here the royal family could view the ceremonies and sporting events taking place below.

Flandin was in Ispahan in 1841 while taking part in a French diplomatic mission led by Comte Edouard de Sercey to the Shah of Persia. He and his fellow artist Pascal Coste were employed to record Persia's ancient and Islamic monuments, and after their return to France they published jointly eight volumes of text and plates entitled *Voyage en Perse*. Flandin had also travelled in Algeria in 1837, accompanying a military campaign by the French as they continued with their war of colonization, and he eventually published his book, *Algérie historique, pittoresque et monumentale*, in 1843.

Femme Turque qui fume sur le Sopha
[A Turkish woman smoking on a sofa]

Plate 45 from Explication des cent estampes qui représentent différentes nations du Levant, Paris

Published by Jacques Le Hay, 1714–15
Etching and stipple after Jean-Baptiste Vanmour
(1671–1737)
V&A: SP.355.45

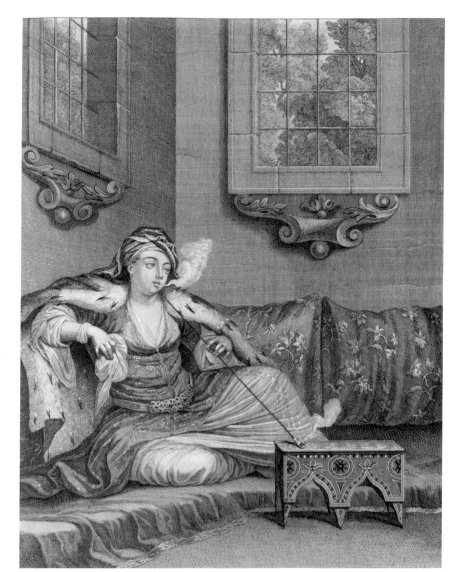

There is a long tradition of ambassadors to the Ottoman court commissioning artists to record their missions. Jean-Baptiste Vanmour, a painter who was born in Valenciennes, met the Marquis de Ferriol in Paris and accompanied him to Istanbul about 1699. Vanmour's speciality was painting the splendid state occasions at which an ambassador first presented his credentials and gifts to the Sultan himself. A number of such oil paintings, starring various ambassadors, survive. Charles de Ferriol was fascinated by the Ottoman court and its officials, and the ordinary citizens as well. He commissioned drawings from Vanmour, showing many aspects of Ottoman life, between 1699 and 1709. First published in book form in 1712, the 100 prints were reissued and copied in many versions subsequently. The French painter Antoine Watteau (1684–1721) used some of the images as a basis for his paintings, and the prints were even used as models for the ceramic Turkish figures made at Meissen in the first part of the eighteenth century.

 This image must be mostly imaginary, because Vanmour could not have seen a Turkish woman relaxing at home, unless he became a Muslim himself and set up his own household (as some artists did). However, since there was a demand for such images, he provided one anyway. It is not all inaccurate, because Ottoman houses of this date seem to have had little furniture, beyond a sofa and carpets to recline on. Everything else, such as bedding and little portable tables for dining, were stored in cupboards until needed, so the rooms appeared uncluttered, light and airy. Women apparently smoked tobacco frequently, using the cooling properties of the nargile or water pipe. They are alleged to have preferred the gently perfumed tobacco of Syria, which was quite different from the harshness of modern Virginia leaf.

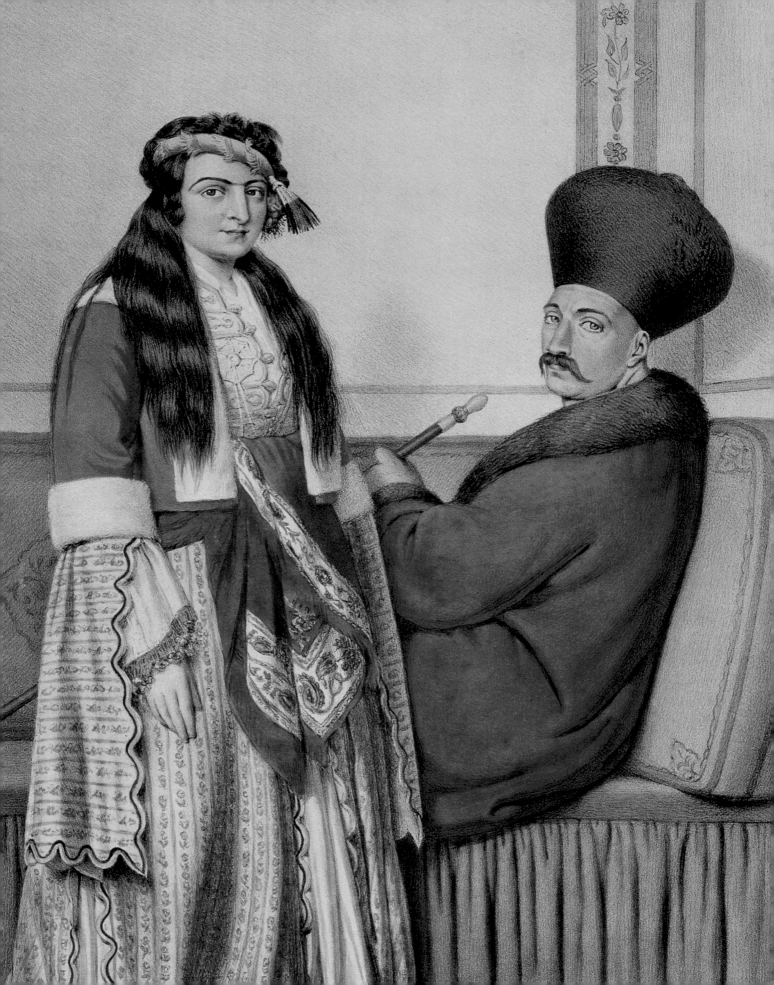

Travellers and Artist-Travellers

Throughout recorded history there have always been individuals for whom the prospect of travel was too strong to resist, and even stronger was the desire to record their journeyings. By the eighteenth century, an essential part of the cultural education of a wealthy young man in Britain was the Grand Tour: an opportunity to travel, see and study the antiquities and culture of Italy and the remains of the ancient Roman world. However, there was also a grander tour increasingly available in the Ottoman dominions, where the lesser-known antiquities of Greece, Egypt and the Holy Land rivalled those of Italy. Travellers like these often wanted images of what they had seen and experienced. The end of Ottoman military expansion at the beginning of the eighteenth century enabled a greater influx of visitors to Turkey. Napoleon's invasion of Egypt in 1798 and the subsequent decline of Mamluk power heralded another invasion of visitors, scientists, archaeologists and eventually (and most numerously) tourists. This resulted in more commissions and employment for many artists.

Some artists in turn illustrated their own travel accounts, and by the middle of the nineteenth century a very wide variety of travellers made and even published images of their travels in a variety of new media. The desire for novel themes for painting provoked the journeying of many artists, reflecting the peculiarly nineteenth-century obsession with originality of subject. There was a real fear of plagiarism that made artists seek to depict the unusual, since novelty in subject matter was considered a major selling point with the art-buying public.

Besides these professional artists were those who drew for their own pleasure or had no need to exhibit their work. They are ambiguously and often unfairly called 'amateurs', though in some cases they were more skilled and better trained than the professionals. The advantage of an amateur's work is that he or she often tried to represent exactly what they saw, rather than something romanticized for a patron. Their choice of subject could be unusual and unconventional, because it might arise out of a specific incident in their travels. In contrast, by the 1850s there were professional artists and photographers who specifically catered for an ever-increasing number of tourists wanting souvenirs of their travels. As well as the usual run of antiquities, manners and customs, portraits of remarkable individuals encountered by the travellers became a popular theme with amateurs and professionals alike.

Hierapolis – Natural Hot Spring, Phrygia

1837
Antonio (Anton Jr or Antoine) Schranz (1801–after 1865)
Watercolour over pencil
V&A: SD934

Antonio Schranz belonged to a family of artists of German origin who had settled in Malta in 1818. Working in Valletta, Antonio was described as a 'paesista e pittore di marina', that is, a landscape and marine artist. He collaborated with his elder brother Giovanni (1794–1882) in the family lithographic establishment that published prints after their watercolours, usually lettered 'Schranz Brothers'. From 1823 to 1847 Antonio made at least ten voyages to the eastern Mediterranean and Egypt, often finding employment as a draughtsman with wealthy British travellers, such as Robert Pashley in 1834 and Viscount Castlereagh in 1842. Later, he also took up photography and as early as 1851 produced picturesque scenes of Cairo.

This image of Hierapolis (modern Pamukkale in western Turkey) was intended as a kind of

souvenir for the unidentified patron and traveller who employed Antonio in 1836–7. As a generalized view, it is a forerunner of the picture postcard. In ancient times Hierapolis in Phrygia was a kind of spa, famous for the healing properties of its hot springs and the temples built to accommodate the influx of worshippers. Below the pool of warm water depicted here are the famous white cliffs, formed into fantastic shapes by the rapid deposition of calcium carbonate from the mineral-rich waters that flowed down into a series of shallow pools and formed stalactites. The Turks called the site Pamukkale ('cotton castle'), and it is now a major tourist attraction. The uninhabited area among the ruins around the pool, as painted by Schranz, is now covered with modern buildings. The Sacred Pool itself is now a swimming pool inside the Pamukkale Hotel.

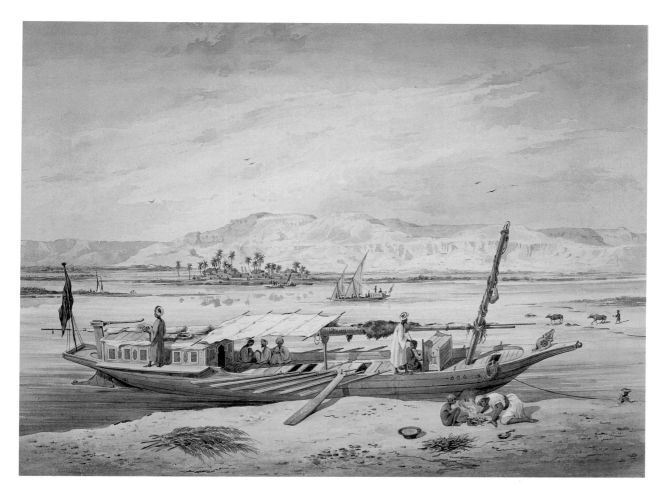

J.W.P.'s Kanja *Moored Beside the East Bank of the Nile at Luxor*

*c.*1840
Achille-Constant-Théodore-Emile Prisse d'Avennes
(1807–1879)
Watercolour
V&A: SD853

Artist, writer, linguist, archaeologist, traveller and engineer, Prisse d'Avennes was one of those extremely active, versatile and highly skilled characters that the nineteenth century often seemed to produce. He was employed by the ruler of Egypt, Muhammad Ali, to assist in the modernization of the army and of irrigation systems, but resigned in 1836. Some disagreement and his impatience of authority soon induced him to work for himself. He became famous among European travellers in Egypt for his knowledge of Egyptian antiquities and his skill in copying important inscriptions and reliefs. In 1843–4 he also secretly removed and shipped to France the King List from the Temple of Amun, Karnak, forestalling a Prussian expedition that also wanted it, and in 1845 received the Légion

d'honneur. Prisse published various books, providing hundreds of illustrations drawn by himself, on the subject of Egyptology, including *Les Monuments egyptiens* (Paris, 1847), and on Islamic culture, notably *L'Art arabe . . .* , published in parts in the years 1869–77. His son Emile Prisse d'Avennes alleged that Prisse had travelled as a Muslim in Arabia and Abyssinia when exploring Upper and Lower Egypt. In order to finance himself in the late 1830s and early 1840s, Prisse accompanied travellers down the Nile, often illustrating the journey for his patrons. This watercolour had inscribed on the mount *My Boat on the Nile J.W.P. By Prise* (*sic*). The view is from the shore at Luxor looking across the Nile to Gabal Qurnat on the west bank. We do not yet know the identity of the traveller J.W.P. who had hired the *kanja* or Nile boat, a favourite way to travel to the antiquities in Upper Egypt. The inscription in English and the red ensign flying at the stern would indicate a British traveller. This kind of picture seems to have become formulaic for Prisse, since similar pictures of *kanja*s with different flags are known.

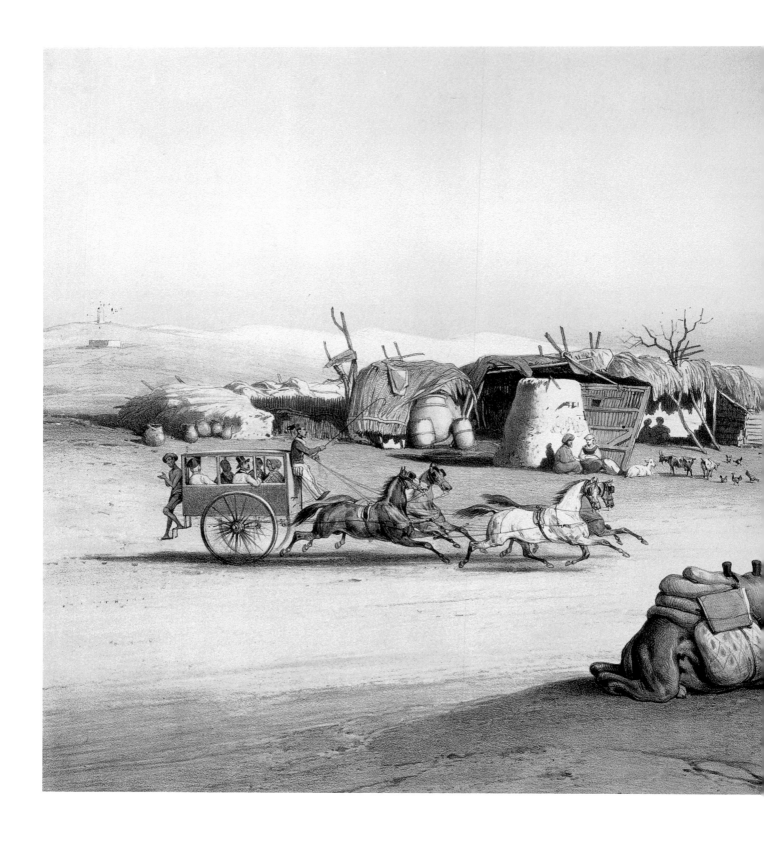

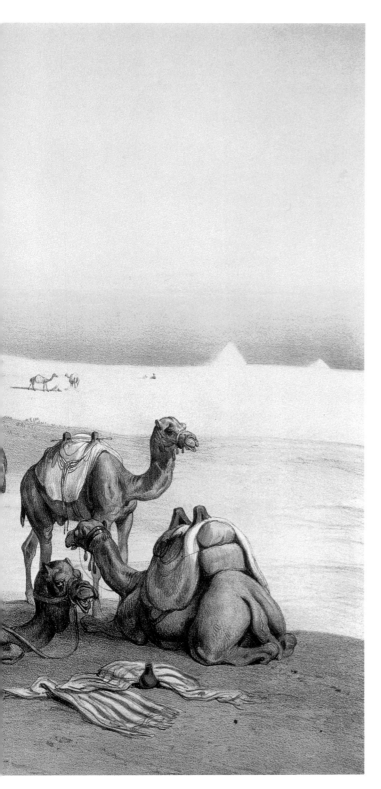

Arab Tanya A Suczi Pusztan
[An Arab dwelling in the desert of Suez]

1859
After Count Mano Andrassy (1821–1891)
Plate from M. Andrassy, *Reise des Grafen Emanuel Andrasy [sic] in Ostindien, Ceylon, Java, China und Bengalien*, Pest, 1859
Colour lithograph, with additional colouring by hand
V&A: SP55

Before the Suez Canal connecting the Red Sea and the Mediterranean was built, the most direct route between Europe and India was the so-called Overland Route. Here a party of well-to-do travellers are seen crossing the short section of desert between Suez and Cairo. In the distance on the right the Pyramids can be seen, and on the left one of the semaphore towers set up to send messages along the route. In the foreground are three camels, representing more traditional means of travel, and in the background an Arab dwelling. The four-horse carriage shown here was the swiftest and most comfortable way for tourists to travel across the desert, in marked contrast to the difficulties that earlier travellers had experienced. Visitors in the 1850s noted that the desert track was now easy to follow because of the thousands of soda-water corks strewn along the route, discarded by thirsty travellers.

Born in Košice (now in Slovakia), Count Andrassy was a wealthy Czech industrialist, draughtsman and traveller who modernized the iron-ore mining and metallurgy industries in the Sajo valley. His extensive travels included a visit to India and China. He subsequently published an account of his journey in Czech in 1853 and in German in 1859. This image is from the German edition. His drawings were turned into lithographs by Eugène Ciceri and Victor Adam, and published in Paris by Lemercier.

View of the Forts of Marani and Jalali at the Entrance to Masqat Harbour

1793
William Daniell RA (1769–1837)
Watercolour over pencil
V&A: SD296

William Daniell was a landscape painter in oils and watercolours, and an engraver, mainly of Indian and British subjects. He had accompanied his uncle Thomas Daniell on an extensive tour of India between 1786 and 1793, assisting him with the watercolours that were later published as *Oriental Scenery* (six parts, 1795–1808). In 1793 the Daniells, intending to return to England, sailed from Bombay (now Mumbai) to Masqat on the Gulf of Oman. Here they heard news of the war between England and France and returned to Bombay, eventually to complete their journey the following year entirely by sea. Among the oils and watercolours of Masqat that they had exhibited at the Royal Academy was William's version of this view, hung in 1831, nearly forty years after their visit. Few European artists visited Masqat, and representations of it are rare.

Both artists made sketches of the picturesque harbour of Masqat, dominated by the two sixteenth-century fortresses built by the Portuguese. After 1500 the Portuguese established a new trading route from the Indies to Lisbon, via the Cape of Good Hope, and attempted by force of arms to establish a trading monopoly in spices and other goods from India and the rest of East Asia. The chain of forts they constructed was very necessary, because their activity threatened the lucrative spice trade conducted by the Mamluks of Egypt. After the defeat of the Mamluks in 1517, the victorious Ottomans in turn mounted attacks on the Portuguese forts as part of their own attempts to dominate the trade.

View of the Theatre of Myra, Asia Minor

1808
Louis François Cassas (1756–1827)
Ink and watercolour
V&A: SD214

Cassas was a skilled draughtsman, a painter of picturesque landscapes and figure subjects, and an indomitable traveller. After studying in France and Italy, he went to Sicily and then joined an expedition to Dalmatia and Istria (modern Slovenia). In 1784 he left France for Istanbul with the Comte de Choiseul-Gouffier, the French ambassador to the Ottoman Empire. Later in 1784 he embarked on a journey to Syria, Lebanon, Palestine, Cyprus and Egypt, returning in January 1786. Later that year he visited Asia Minor and the Greek Islands, returning to Rome in 1787. He settled in Paris in 1791–2, where he published several large volumes of engravings after sketches made on his travels.

The ruins in this watercolour are recognizable as those of ancient Myra in Lycia, now modern Demre on the south-west coast of Turkey, but the lush vegetation, the numerous trees, the lake and the waterfalls are a fantasy. Romantic ruins were seldom romantic enough in reality to satisfy the intense longings for an imagined golden age that many classically educated patrons, like the ambassador, shared. In the eighteenth century there was a prevailing belief that Nature could safely be improved on, and so the artists obliged. As is common in the work of Cassas, the groups of Turks and Greeks smoking, picnicking or making music act merely as additional decoration or 'staffage' giving a sense of the scale of the picture. However, the Turks did (and still do) like to take their *keyf* or placid enjoyment in the open air, so Cassas would have seen and sketched such gatherings in his travels.

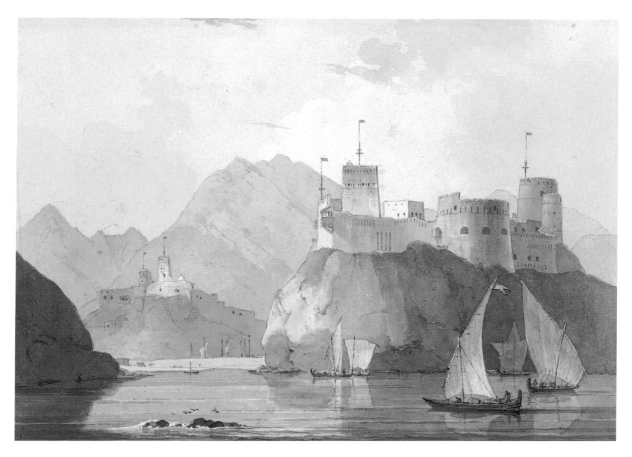

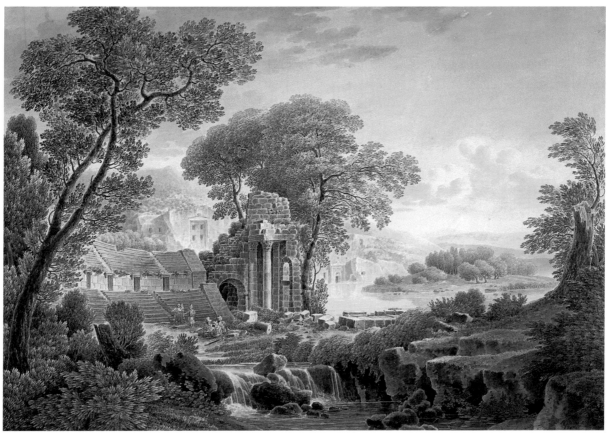

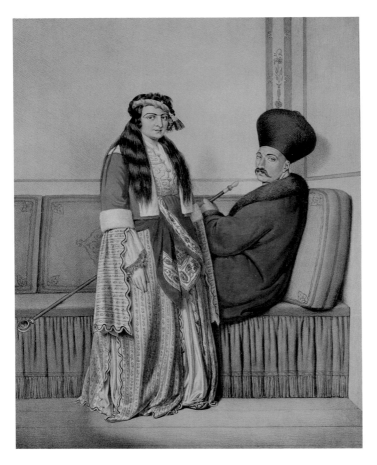

Constantinople are remarkable for their excellent drawing and skilful hand-colouring. The volume, consisting of 40 plates with text, shows a variety of people and costumes, mainly of Greek origin. This set of prints finally proved that lithography, invented only 18 years before in 1797, had progressed to a stage where it could be used in the highest-quality publications, displacing the technique of etching with aquatint that had dominated coloured book illustration until then.

Un Prince arménien et sa femme
[An Armenian prince and his wife]

Louis Dupré (1789–1837)
Plate 33 from a set of 40 from L. Dupré, *Voyage à Athènes et à Constantinople*, Paris, 1825
Lithograph, coloured by hand
V&A: SP236

Apart from the headdress, the woman's costume, complete with an elaborate embroidered shawl tied around the waist, is typical of that worn by Ottoman women of the time, whether Christian or Muslim. The man's distinctive hat was worn by wealthy Armenians, as was the green fur-trimmed robe. They are shown in a plain but elegant interior, and he is holding a very long *çubuk* (cornel-wood tobacco pipe), which most males seemed to use in Ottoman times.

Dupré, a painter, miniaturist and lithographer, was born in Versailles and was a pupil of the painter Jacques-Louis David. He embarked on a journey with three Englishmen, Hyett, Hay and Vivian, to Greece and Istanbul in 1819, and thence to Bucharest with the Prince of Moldavia, eventually returning to Paris. His lithographs published in 1825 in *Voyage à Athènes et à*

Fountain of Tophane
[Tophane Çeşmesi], *Istanbul*

1829
William Page (1794–1872)
Etching and aquatint, printed in brown and green, with additional colouring by hand
V&A: SP443

This large print is a fairly accurate image of the fountain built in 1732 by Ahmed Ağa, an architect in the service of Sultan Mahmud I. Istanbul once had hundreds of street fountains, large and small, which were a neighbourhood's source of water and inevitably a local meeting place. Muslims considered it an act of piety to pay for the construction of a fountain, a free water supply for one's fellow citizens, and many of these *sebil*s have commemorative inscriptions as well as intricately carved decoration on their marble slabs. The original watercolour for this print was exhibited by Page at the Royal Academy in 1825 with a companion picture of the Fountain of Ahmet III (situated next to Topkapı Sarayı), probably identifiable with a watercolour in the Searight Collection.

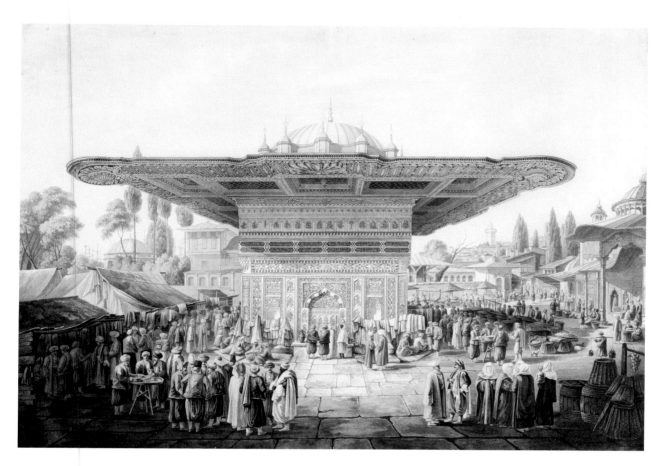

These fountains were both magnificent examples of Ottoman Baroque architecture. The dome and widely overhanging eaves of the Tophane Çeşmesi were later damaged, and although the building has recently been restored, Page's aquatint shows it in its original splendour. Architectural historians have speculated that the delicate marble sculpture was once brightly coloured, especially the rows of carved fruit trees under the eaves, and in fact this print shows that in the early nineteenth century it was indeed painted. The fountain, beside the Mosque of Kılıç Ali Paşa, was the centre of life in the locality. The busy street market seen here includes traders selling clothes and other textiles, fruit and vegetables, and perhaps refreshments such as *mahallebi* (milk puddings). This fountain used to stand near the water's edge, on the busy dock side near the Tophane or Arsenal, but this dock area has been filled in and radically changed, so now the fountain is some distance inland and the street market has disappeared.

Very little is known about Page. He first visited Greece and Turkey in the years 1816–24, and may have travelled there later in the 1820s and '30s. These trips provided material for numerous picturesque scenes of local people and buildings, much in demand at this time, of which there are several in the Searight Collection. Hand-coloured aquatints, with their range of subtle tones, if produced by skilled printmakers, closely resembled the watercolours they reproduced. Page seems to have tried to represent the fountain, the marketplace and the inhabitants without much stylization or any caricature, although within the artistic conventions of his time.

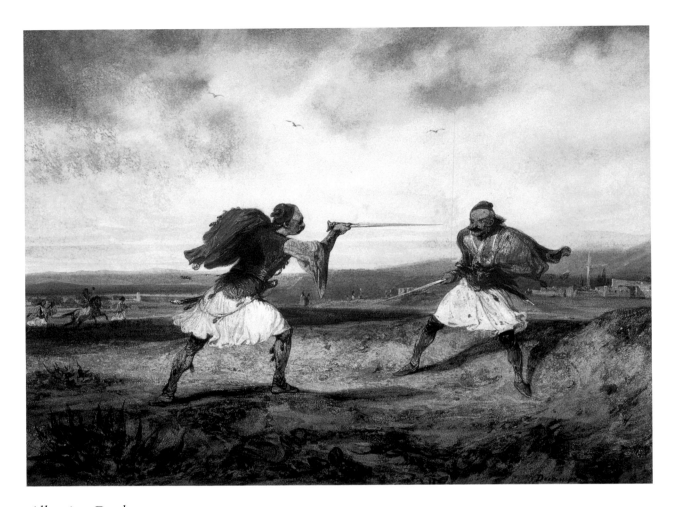

Albanian Duel

*c.*1829
Alexandre-Gabriel Descamps (1803–1860)
Watercolour and body colour, with gum, heightened with
white
V&A: SD304

War-like Albanians, dressed in flowing garments
and festooned with daggers, pistols and swords,
were a favourite subject for Romantic artists, and
Byron chose to be represented in Albanian cos-
tume in his famous portrait by Thomas Phillips
(Government Art Collection, British Embassy,
Athens; replica in National Portrait Gallery,
London). In the early nineteenth century
Albanians were alleged to be the fiercest section
of the Ottoman forces, and indeed there are
many travellers' descriptions of their alarming
appearance. In this watercolour, Descamps has
focused on the tension between the two combat-
ants as they glare fiercely at one another and
parry with their distinctive short swords
(*hançer*). Each goads the other on while their
cloaks and white kilts (*fustan*) swirl about them.

The drama is enhanced by the men and galloping
horses approaching from the background, hoping
to intervene before the outcome proves fatal.

Descamps's oriental subjects resulted from a
trip to Greece, Albania and Turkey in 1827–8. In
his lifetime Descamps became almost as famous
as that better-known Romantic painter Eugène
Delacroix. Naturally, Descamps has here deliber-
ately chosen a highly charged subject that he
knew would appeal to the Romantic ideas of
his patrons, yet it is quite possible that he did
witness a duel such as this. Duelling caused by
alleged slights of honour appeared frequently in
many cultures, and in that same year of 1829 the
Duke of Wellington (in plainer costume) fought
a duel with Lord Winchilsea in the swampy
wasteland of Battersea Fields.

A Bayadère *from Shemakha in Azerbaijan*

*c.*1842
Prince Grigoriy Grigorievich Gagarin (1810–1893)
Watercolour and body colour over pencil
V&A: SD406

The son of the Russian ambassador to Rome, Gagarin studied art in Italy. He returned to St Petersburg in 1832 and then went on diplomatic missions to Munich and Istanbul. He travelled in the Caucasus, which was then increasingly coming under Russian control. This remote and mountainous region was seldom visited by western artists in the nineteenth century, so Gagarin's drawings made in the 1840s are a valuable record of the traditional costumes of the people of Azerbaijan and Georgia. Although this drawing is carefully annotated with notes on the costume, colouring and other details, it is not reproduced in either of the volumes of coloured lithographs that Gagarin published in Paris between 1845 and 1850, entitled *Le Caucase pittoresque* and *Scènes, paysages, moeurs et costumes du Caucase.*

He depicts here a dancing girl from Shemakha, west of Baku. They were famous for their grace and beauty, and for the sensuality of their dancing. Gagarin uses the French word *bayadère,* which was applied to Hindu dancing girls, although it was a word ultimately Portuguese and not Hindi in origin. Gagarin may have been influenced by a production of *Le Dieu et la bayadère,* an opera-ballet first performed at the Paris Opéra in 1830. In its depiction of an attractive woman in her dance costume, this watercolour is somewhat reminiscent of the very popular colour lithographs of famous ballet dancers and opera singers on the front covers of sheet music. These were ostensibly sold as music covers in Paris and London in the 1830s, but in fact functioned as a polite form of pin-up.

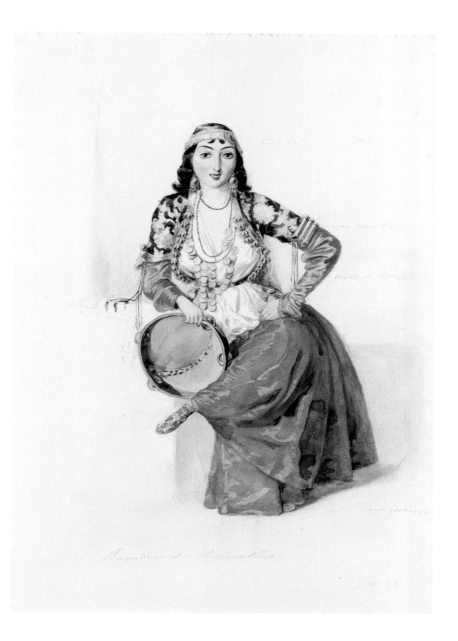

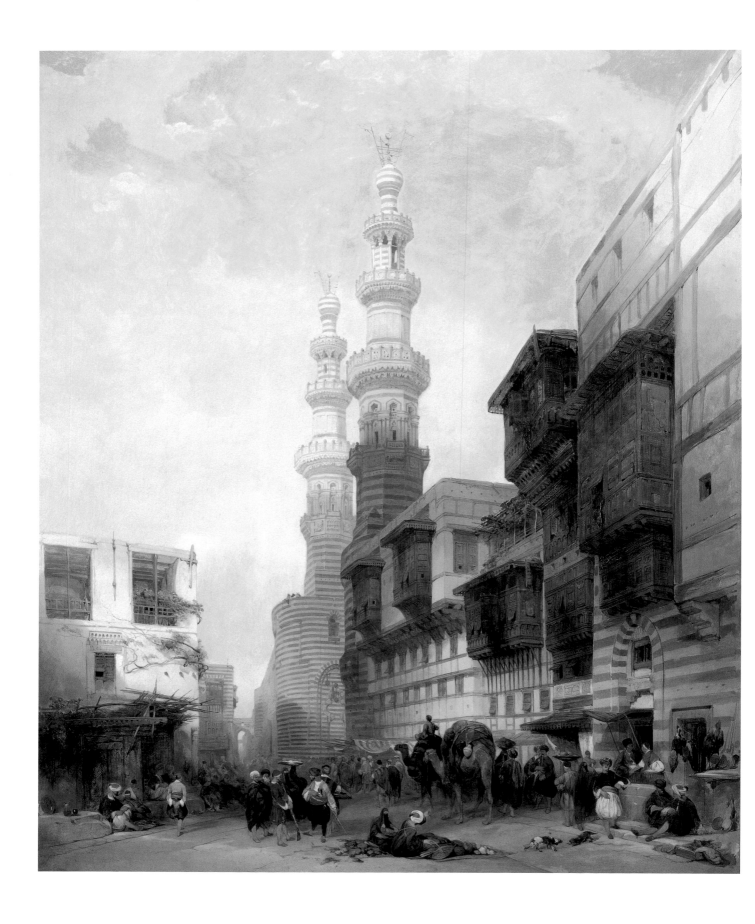

The Gate of Cairo, called Bab-el-Mutawellee

1843
David Roberts RA (1796–1864)
Oil on panel
V&A: FA.176

Oil paintings illustrating the lands mentioned in the Bible became more popular in the first half of the nineteenth century. This was due in part to religious revivals in Britain, and partly to the increasing accessibility of Palestine and Egypt for artists and other visitors. Egypt as a source of subjects for painters provided both the stupendous ruins of the Egypt of the Pharaohs and the splendid buildings of medieval Cairo. The district of Grand Cairo depicted here is Bab Zuwayla, one of the three main gates of the city, built in 1092. This was also known locally as Bab Mutwalli (hence Roberts's title). The twin minarets above the gate are those of the Mosque of Sultan Mu'ayyad Shaykh, built just inside the gate between 1415 and 1421.

David Roberts spent six weeks working in Cairo, intending to balance his covering of Egypt's ancient temples with paintings of the country's Islamic architecture. His skill in dramatically rendering both the architecture and the lively street scene owes much to his early work for the theatre and opera. He first made his name in London in the 1820s as both a designer and painter of stage sets and panoramic backdrops at the Theatre Royal, Drury Lane, and at Covent Garden.

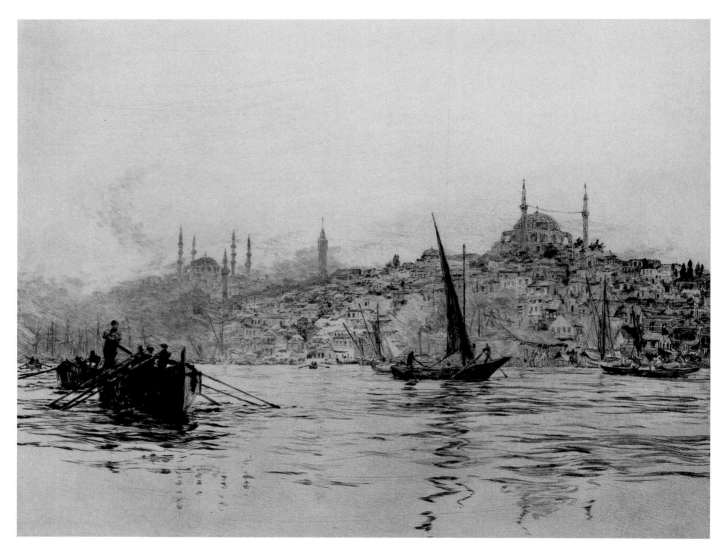

The Golden Horn, Constantinople

*c.*1910
William Lionel Wyllie RA RI (1851–1931)
Drypoint
V&A: SP659

This view of the Golden Horn at Istanbul was an unusual subject for Wyllie, yet there were resemblances between it and one of his favourite localities, the Pool of London. The Golden Horn was also full of the world's shipping, and the precise locality in that harbour was pinpointed by well-known landmarks. Whereas St Paul's Cathedral would set the scene in London, here the skyline is dominated by the minarets of two huge mosques, the Süleymaniye on the left and the Fatih Camii on the right, with the Serasker (War Ministry) Tower in the centre.

In Britain, a small island, where the huge spread of empire had been made possible only by its massive fleets of shipping, maritime imagery was an important part of the repertoire of many artists. Wyllie was a marine painter in oils and watercolours, an illustrator and etcher. He had been trained at the Royal Academy Schools, but he also studied shipbuilding to help him with his paintings, since authenticity of detail was frequently demanded by many patrons who had been to sea themselves. His marine paintings and etchings were much admired in his lifetime, and, after a period of neglect, they are once again popular. He portrayed all manner of sailing and steam craft and is particularly renowned for his atmospheric views of the Thames and Medway.

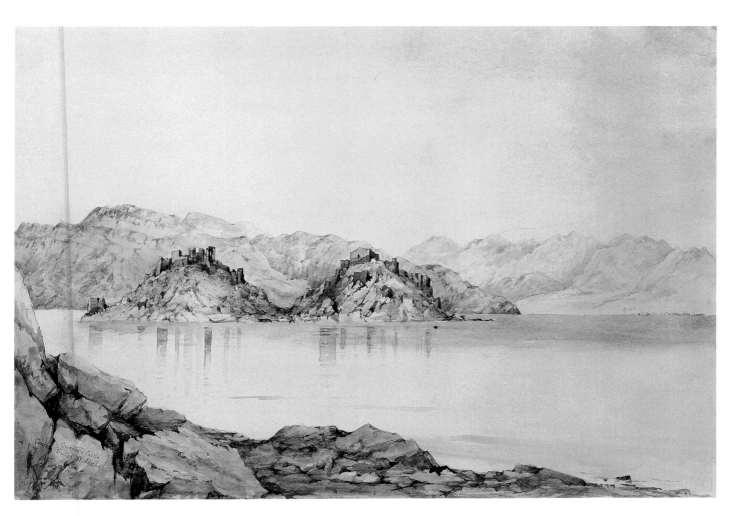

The Crusader's Castle, Island of Graia
[Gazirat Faraun, Ayla, Gulf of Aqaba]

1857
Maria Harriett Mathias (née Rawstorne)
Watercolour over pencil
V&A: SD633

Ayla, a site now in Jordan, near the head of the Gulf of Aqaba, was originally a Roman settlement. It was taken from Byzantine control by the Muslims, then during the twelfth century captured by the Crusaders. About 1115 Baldwin I of Jerusalem built a castle on nearby Gazirat Faraun (Pharaoh's Island). When Saladin recaptured Aqaba in 1182, the castle became known as Saladin's Castle. The fortifications were rebuilt by the Mamluk Sultan Qansweh El-Ghuri (ruled 1501–16) and then it came under Ottoman control.

Although Maria Harriett Mathias is categorized as an amateur artist, this description does not do justice to her skill as a watercolourist. Very little is known about her life or work, simply because she was a woman, and did not need to sell or exhibit her paintings. Typically, she is recorded (in *Burke's Landed Gentry*) only because she married James Mathias (b.1823) of Catisfield Lodge, Fareham, Hampshire. According to a fragment of her diary, in 1856–7 Maria, with her husband and 'Eddy' (probably her brother-in-law, Edward Mathias), toured through Italy to Egypt and on through Syria, Palestine and Lebanon. Paintings or drawings of this particular castle are very rare, surprisingly so, given its architecture, location and history. This watercolour was part of an album of views, mainly of Egypt, that Maria made on her tour.

A Turkish Coffee House, Istanbul

1854
Aloysius Rosarius Amadeus Raymondus Andreas, known
as Amadeo, 5th Count Preziosi (1816–1882)
Pencil and watercolour heightened with white
V&A: SD824

Preziosi was of noble Maltese birth, but against
the wishes of his family he rejected their chosen
profession of the law to become an artist. From
1842 until his death 40 years later he lived and
worked in Istanbul, and was renowned for his
vibrant and evocative images of all the different
races and cultures of that most cosmopolitan
of cities. He became for a time well known
in western Europe, because many travellers
(including, in 1869, the Prince of Wales) took
his pictures home as souvenirs of their visit.
Demand for his work prompted the publication
in Paris in 1858 of a series of lithographs,
Stamboul Recollections of Eastern Life.

This is a fine example of Preziosi's keen obser-
vation of contemporary Ottoman life, rapidly
sketched yet full of accurately depicted detail.
A large gallery of characters is portrayed, all
of them evidence of the cosmopolitan character
of nineteenth-century Istanbul. On the left can
be seen a *saz* (group of musicians), a Greek
with a long *çubuk* (long cornel-wood pipe) and
an African youth applying a glowing piece of
charcoal to the bowl, carrying at the same time
a *nargile* (water pipe), as well as a *Mevlevî* or
whirling dervish in his distinctive conical *külâh*
(felt hat). In the background are merchants,
including a Persian. In the foreground is another
merchant with a *çubuk,* and at the door an
unveiled beggar-woman on her rounds. To their
right are a Circassian with cartridges on the
front of his coat and two more Greeks smoking.
The coffee house itself is a luxurious nineteenth-
century Baroque structure, probably on the
shore of the Golden Horn. The coffee-house
equipment is clearly shown: on the left a row of
nargile with some spare tubes and a large water-
pot; behind them, in the corner, the stove for
heating the coffee and the charcoal for the pipes.
Next to the Greek in the right foreground are a
coffee cup and its metal holder. In the centre is
an elaborate fountain, which cooled the room
in summer.

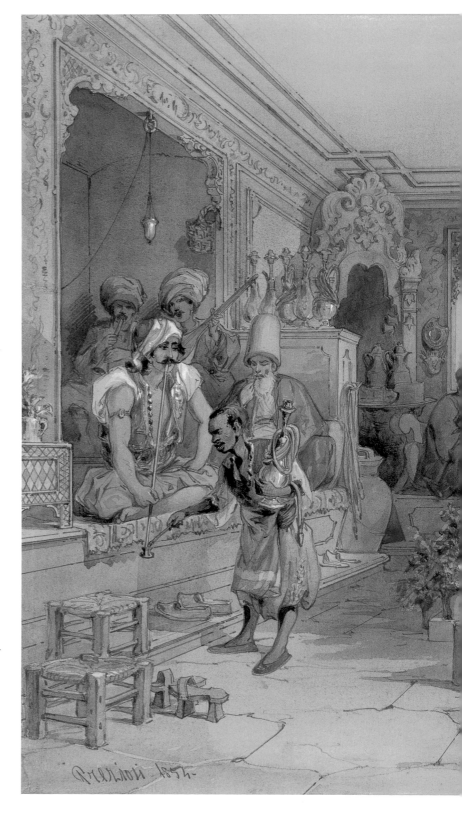

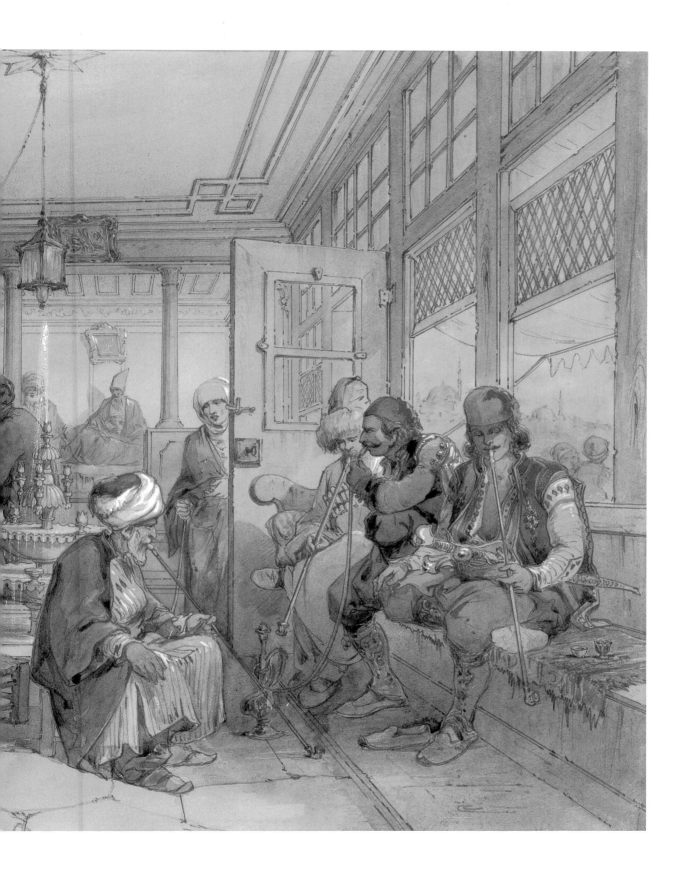

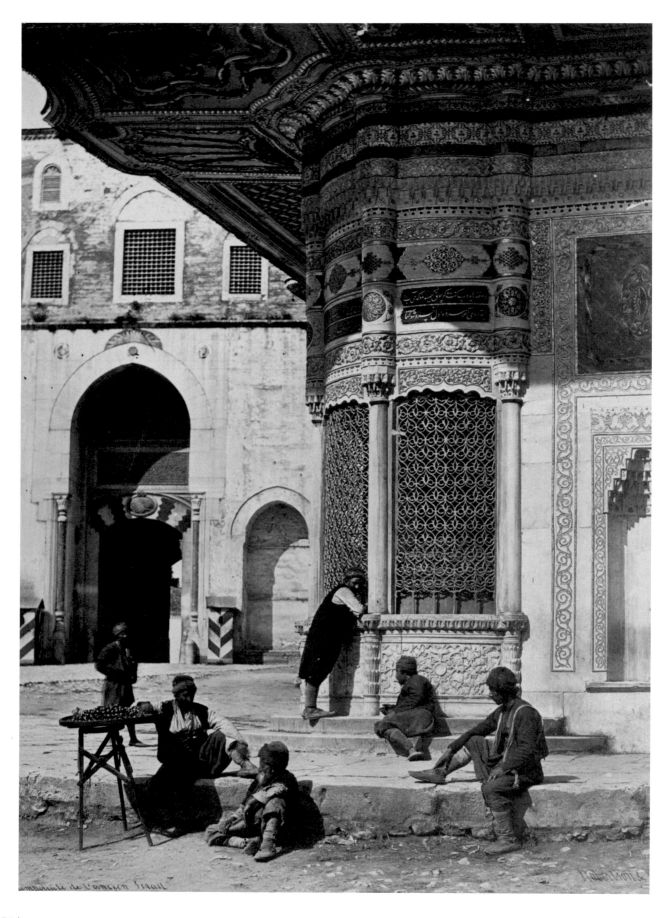

*Fountain of the Seraglio,
Constantinople*
[View of the fountain of Ahmed III
by the gate of the palace of Topkapı,
Istanbul]

*c.*1860.
James Robertson (1813/14–1888)
Collodion print
V&A: 2988–20

The painter Paul Delaroche is famously alleged to have said 'A partir d'aujourd'hui la peinture est morte' ('From today painting is dead') when he first saw the photographic process called a daguerreotype, invented in 1839. Perhaps this is indeed only a legend, because he subsequently continued to pursue a successful career as a painter and also actively promoted the new cause of photography. The belief that photography would immediately replace painting and drawing was mistaken, even though many miniature portrait painters had to retrain quickly as portrait photographers in order to make a living. From the beginning photography was regarded as a useful form of printmaking. One of its early names was 'solar mezzotint', as if it were a modern version of a historic continuous-tone engraving technique, but powered by the light of the sun.

Photography could not rival painting at first, since it produced a fugitive, faint, black-and-white image, exquisite in detail but lacking in colour. It could be hand-coloured, like the other printmaking processes, but the original image could be selected only and not easily manipulated. This image of the fountain of Ahmed III is a good example of its advantages and disadvantages. The monochrome image suggests an air of dereliction and decay, even when precisely and rapidly rendering the details of the architecture. There is no colour and life that a painter might suggest, and the street vendors are shown only as part of a scene of poverty. Whereas a painting might emphasize the picturesque nature of their costume and their wares, this photograph emphasizes the idea of listless squalor. Because of the slow exposure times of the early photographic process, the figures had to keep still and restrain any show of animation.

The belief that photography is a completely truthful medium (unlike the fictions of painting) persisted with the early enthusiasts of photography, yet a photograph can be as misleading as any other image. It is literally a reflection of some kind of reality, but distorted by the bias of the photographer. The camera operator could choose what to photograph, and reduce it to a lens-interpreted black-and-white image of two-dimensional marks on paper, often with more confusing detail than was required for artistic effect or information. It could not replace the very subtle discrimination of direct human sight, which is why to this day details of archaeological excavations are still drawn by hand, since photographs cannot automatically select the important details and omit the irrelevant. Yet its value to architectural historians as a means of recording a structure rapidly was extremely important. Indeed, this particular print had been purchased for use by the architect Richard Phené Spiers (see p.75).

Photography as an art rose and fell in general estimation by the end of the nineteenth century, with the invention by 1900 of instantaneous cheap cameras that anybody could operate. Although it had become an essential modern technology at the beginning of the twentieth century, it was rediscovered as a major nineteenth-century art form, complete with museum exhibitions, only in the 1960s. A great enough expanse of time has elapsed so that any views of a vanished past are now valued, no matter what the medium or the artist.

James Robertson trained as an engraver of coins and medals under William Wyon at the Royal Mint in London, and was recruited (with others) by Sultan Abdulmecid in 1841 to modernize the Imperial Mint in Istanbul. About 1853 he took up the new process of photography, and in 1855 went into partnership with another photographer, Felice Beato, whose sister he married in the same year. He continued to work at the Mint and take photographs of Istanbul and other cities in the Ottoman Empire until the business was sold in 1867. He retired from the Mint in 1881 and then went to Japan to rejoin Beato, who had settled in Yokohama. His photographs of the cities were mainly architectural, although he did also record some of the aftermath of the Crimean War at Sebastopol.

46

On the Pyramids

*c.*1860
Felice Beato (1825–1908)
Collodion print
V&A: PH.2692–1900

This vertiginous image should be compared to
the depiction of the same tourist attraction by
William Simpson (see p.110). For his photograph,
Beato has exploited the strong raking light and
consequent shadow, and the monumental nature
of the core masonry of the pyramid. The pyra-
mids were originally covered with ashlar, a
smooth limestone facing of polished squared
stones, but most was stripped off and recycled
to build the medieval city of Cairo.

Felice Beato made photographs in Japan, India,
Athens, Istanbul, the Crimea and the Holy Land.
He eventually moved to Yokohama in 1863, and
after 1877 settled in Burma. Among the wars he
depicted in photographs were the Indian Mutiny
and its aftermath in 1857 (with his partner,
James Robertson). He subsequently pho-
tographed the Opium War in China in 1860
and colonial wars in the Sudan in the 1880s.

Camp Attendants, Beirut, May 7th

1862
Francis Bedford (1816–1894)
Collodion print from the set *Tour of the East*
V&A: 53.759

Francis Bedford had begun as a skilled architec-
tural draughtsman and then turned his drawing
talents to lithography. Working for the firm of
Day & Sons, he drew a large number of the
plates for the *Grammar of Ornament* (1856) by
Owen Jones, who acknowledged the high quality
of Bedford's technique. Bedford experimented
with photography about 1853, and his reputation
was established when Queen Victoria and Prince
Albert bought examples of his work from the
first annual exhibition of the Photographic
Society, of which they had recently become
patrons.

Bedford carried out various commissions for
the queen, and eventually was so advanced in
royal favour that in 1862 he was sent to record
the Prince of Wales's tour of the Mediterranean,
Egypt, the Holy Land and Syria. From a com-
mercial point of view, the combination of the
unusual subject matter and the connection with
royalty was irresistible. From the 200 negatives
he made (including this one) Day & Sons
produced portfolios, sold at the tremendous
mid-nineteenth-century price of 43 guineas.

Portrait of Mr Levett in Turkish Costume

*c.*1740
Jean-Etienne Liotard (1702–1789)
Pastel
V&A: FA.187

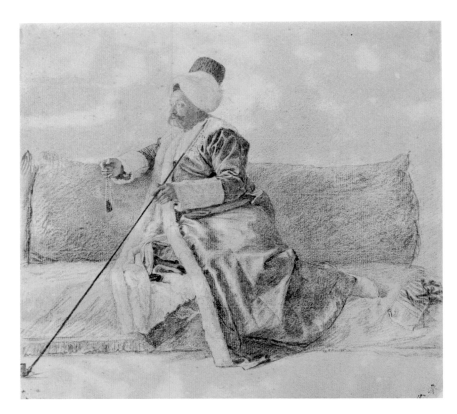

This remarkable portrait is typical of the realism of Liotard's portraiture. The sitter with his distinctive droopy moustache has been identified as a Mr Levett, a close friend of the artist. He was a British merchant in Istanbul, alleged to have adopted the dress and lifestyle of a wealthy Turk in order to socialize with Ottoman officials and dignitaries who might either help or hinder his business. It could be that he also enjoyed, as many expatriates did, wearing sumptuous robes and reclining on a comfortable sofa, while inhaling the cool and scented smoke from his *çubuk* and playing with his *tesbih* or prayer beads. Liotard reused this portrait of Mr Levett (left) for another, more famous, oil painting, now in the Louvre in Paris (right): this time he is reclining on the same sofa listening with every appearance of enjoyment to young Mlle Hélène Glavani, also dressed in splendid Ottoman costume. She is playing a *tambur-i kebir-i türki*, a large stringed instrument similar to a mandolin.

Liotard was born in Switzerland and studied in Geneva and Paris. He travelled to Italy, and in Florence he met Sir William Ponsonby (1704–1793), later 2nd Earl of Bessborough, whom he accompanied to Istanbul in 1738. Liotard spent four years in Istanbul, making a number of sketches of the British merchants and their families based there. He was fascinated by Ottoman male and female costume, and brought back not only studies but examples of Ottoman dress to France, Austria and Britain. There was a fashion in France and England for dressing up in Ottoman costume, and Liotard took full advantage of it. His portraits, whether posed in eastern or western dress, whether of the Empress Maria Theresa or a serving girl with a chocolate pot, all possess an intense and sober realism. As a kind of self-advertisement, Liotard habitually wore Ottoman robes and grew his beard very long, giving him a rather eccentric appearance and the title of 'the Turkish Painter'.

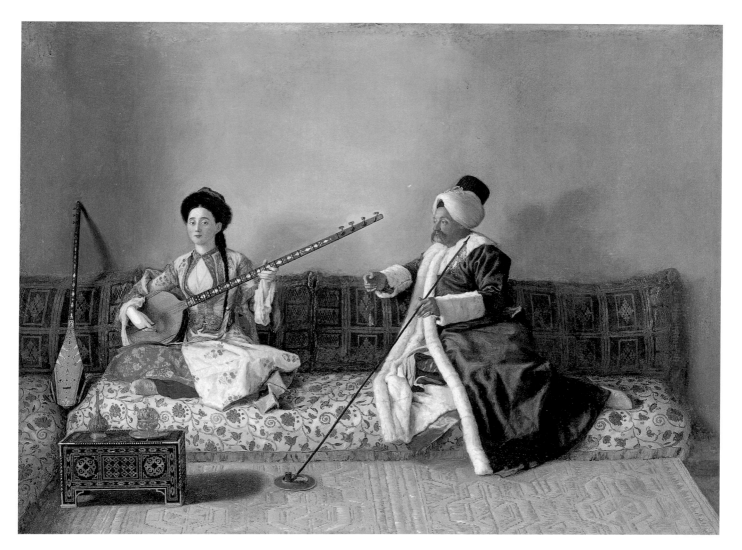

Portrait of Mr Levett and Mlle Hélène Glavani

*c.*1740
Jean-Etienne Liotard (1702–1789)
Oil on board
Musée du Louvre, Paris

Halakoo Mirza, the Persian Prince
[Portrait of Prince Hulugu Mirza]

1843
After Sir David Wilkie RA (1785–1841)
Plate 7 from *Sir David Wilkie's Sketches in Turkey, Syria & Egypt, 1840 & 1841*
Lithograph, with two tint stones and coloured by hand
V&A: SP652.7

David Wilkie and John Frederick Lewis were both in Istanbul in 1840, and both had visited and produced several portraits of the prince, his servants and his new Circassian slave girl. Prince Hulugu, the cousin of the reigning Shah of Persia, was in exile, since his father had tried unsuccessfully to seize the throne. According to Wilkie, the prince was 'living at Constantinople on a pension allowed him by the Turkish Government. Having been active in political intrigue, his return to his native country would be unwelcome to the existing power, and dangerous to himself.'

Wilkie had been highly acclaimed for scenes of Scottish rural life and later for more topical subjects such as *Chelsea Pensioners Reading the Gazette of the Battle of Waterloo* (1822), commissioned by the Duke of Wellington. In the years 1825–8 he travelled to Paris, Italy, Germany and Spain and subsequently painted several historical pictures, and in 1840–41 he visited the Near East to study the settings of biblical events and find authentic-looking models. Wilkie, a devout Christian, had even wanted to use the noble head of the prince as a model for a figure of Christ. Unfortunately, he died on board ship on the way back to England and was buried at sea. His sketchbook, mainly of portraits and scenes of everyday life, was faithfully reproduced as this series of lithographs by Joseph Nash, who managed to preserve the spontaneity and vigour of Wilkie's sketching and watercolours. Although he never realized his planned series of biblical pictures, the lithographs remain the best monument to Wilkie's work in the Ottoman lands.

A Startling Account, Constantinople

1863
John Frederick Lewis (1804–1876)
Oil on panel
V&A: 1005–1886

At first sight, this painting is an exotic and
rather subtle version of what must have been a
fairly common Victorian domestic drama. In
a Turkish interior, a richly dressed Persian is
upbraiding his shifty-looking servants, having
been presented with alarmingly high household
bills. For some unexplained reason, Lewis does
not indicate that it is also a portrait of Prince
Hulugu Mirza, an exile and the cousin of the
reigning Shah of Persia. This ambiguity of
narrative is typical of Lewis.

Lewis and the painter David Wilkie were
both in Istanbul in 1840. Both had visited and
produced several portraits of the prince and
his household. The pension from the Ottoman
Government may not have been big enough to
pay all the bills, especially since the prince had at
least two houses and a new slave girl. Although
Wilkie had wanted to use the noble head of the
prince as a model for a figure of Christ, Lewis
(perhaps aware of Wilkie's intention) slyly
portrays the prince as an all-too-human being.

النبى عبد القادر
المغربى

Cairo March 16
1844

Sheikh Abd Kadir
the Magrabi the Magician of Egypt

Shaykh Abd al-Qadir al-Maghrabi

1844
Godfrey Thomas Vigne FRGS (1801–1863)
Pencil and watercolour
V&A: SD1148

Well-documented magicians are not very common, but Shaykh Abd al-Qadir al-Maghrabi, the so-called Magician of Egypt, was described by many travellers to Cairo in the second quarter of the nineteenth century. He is known to have held seances in the presence of Henry Salt, Joseph Bonomi, Edward Lane, Sir Gardner Wilkinson, Leon de Laborde, Lord Prudhoe, Eliot Warburton, Isabella Romer, Colonel Barnet, John Frederick Lewis and many others. Edward Lane, the author of the *Manners and Customs of the Modern Egyptians* (1836), inadvertently made him famous by describing in that book a seance held in 1833, in which the Shaykh seemed to give extraordinarily accurate answers to questions about people back in Britain he did not know. The central part of the ritual was that a young boy was selected at random and was instructed to stare at a drop of ink that had been placed in his palm. The boy 'saw' images in the drop and answered questions relayed to him via the Shaykh.

Lane was initially enthusiastic about this display of magic, and he and others confessed that they were unable to explain how the Shaykh did it. Over the years, however, they grew increasingly sceptical about the Shaykh's powers. As a visitor attraction, mentioned even in the Cairo edition of *Murray's Guidebook*, the Shaykh lasted for about 20 years, towards the end giving ever more hopeless sessions and rarely recapturing the amazing accuracy of the early days. Interest in what was called mesmerism was then at its height, and a somewhat similar session in Paris in the 1840s, using a French medium, is recorded by the Revd Chauncey Hare Townshend, a major benefactor to the South Kensington Museum.

Vigne was an amateur artist and tireless traveller of Huguenot descent. He travelled in Britain and continental Europe, North America, Turkey, Persia, India, Kashmir, Baltistan, Ladakh, Afghanistan, Egypt, Palestine, Syria, Norway, the West Indies, Mexico and Nicaragua, publishing accounts of his travels. His watercolour portraits of those he met on his journeys are now of great anthropological and historical interest.

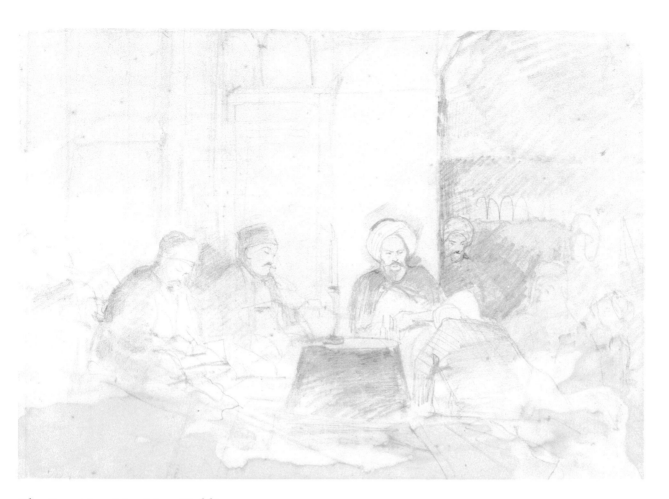

The Egyptian Magician Holding a Seance with Members of the European Community in Cairo

*c.*1846
John Frederick Lewis (1804–1876)
Pencil and red chalk
V&A: SD586

Although this is the roughest of drawings, a composition sketch or simply on-the-spot note-taking, it is included because it actually shows the 'Egyptian Magician', Shaykh Abd al-Qadir al-Maghrabi, in action, possibly in Lewis's house. The Shaykh is clearly visible in the centre, and the huddled form in front of him indicates the young lad kneeling and staring at the drop of ink in his palm, answering difficult questions put to him by onlookers. Although the onlookers are in eastern dress, they are identified on an old label as prominent members of the European commu-

nity in Cairo, including Henry Abbott, Joseph Bonomi and Colonel Barnett, the British Consul-General in Egypt. Alas, if Lewis took his Magician picture idea to another stage, it has not yet been rediscovered. The drawing also demonstrates how Lewis often began his pictures with the roughest of ideas dashed down on the spot, and then slowly worked them up into the paintings of exquisite finish that made him famous. Although a number of these very rough sketches survive, most seem to have been lost or destroyed.

Portrait of Mehmet Ali Pasha

*c.*1842
John Frederick Lewis (1804–1876)
Pencil and watercolour
V&A: Circ.16–1930

Mehmet Ali Pasha, an Albanian Muslim, was
Governor of Egypt, theoretically owing alle-
giance to the Turkish Sultan, but in fact ruling,
and ruthlessly modernizing, the country as an
autocrat. He had treacherously slaughtered the
leading Mamluks, the previous rulers, in 1811
(see p.104). David Wilkie was commissioned by
Mehmet Ali to paint his portrait, and Lewis also
sketched him and members of his family. Lord
Elphinstone, Governor of Madras, mentions this
portrait in a letter to Lewis's brother Frederick
Christian in Mysore, dated 24 September 1845:

> . . . I had again the pleasure of seeing your
> elder brother on my way out last winter.
> He was living in the most Ottoman quarter
> of Cairo – in a house which might supply
> materials for half the Oriental Annuals and
> manuals of Eastern architecture that appear
> in London & Paris. He showed me a very
> spirited sketch of Mehemet Ali – the best,
> & in fact, the only good likeness I have seen,
> & I saw it within a quarter of an hour of
> leaving the original.

Âdile Hanım, a Turkish Woman from Istanbul

1854
Aloysius Rosarius Amadeus Raymondus Andreas, known
as Amadeo, 5th Count Preziosi (1816–1882)
Pencil and watercolour
V&A: D.34–1900

This sensitive study is one of a very few
straightforward portraits by European artists of
Turkish women, who at this time would not
normally unveil themselves in front of a Turkish
male, let alone a Frankish infidel, unless he was
related in the correct degree. We know that she
is Turkish because the inscription in Italian states
Hadilé Hanum Turca di Constantinopoli 1854. It
is not known how Preziosi managed to take this
likeness, but the friends he made among the
Turks may have helped. There is also the possi-
bility that Âdile Hanım might have been an
Alevi, an unorthodox Muslim who on occasion
did not wear a veil. Âdile's face is the reality
that visiting western Europeans tried to glimpse
behind the veils that women wore in the street.
Her broad firm face and steady gaze belie the
image of the simpering beauty that existed in
the untutored imaginations of painters who
had never visited the East. This portrait is from a
series of 31 by Preziosi, acquired by the Museum
in 1900, that were once bound together in an
album. They show a great variety of visitors to
Istanbul, some from as far away as India and
Abyssinia, as well as representatives of the
various peoples living in the Ottoman Empire.

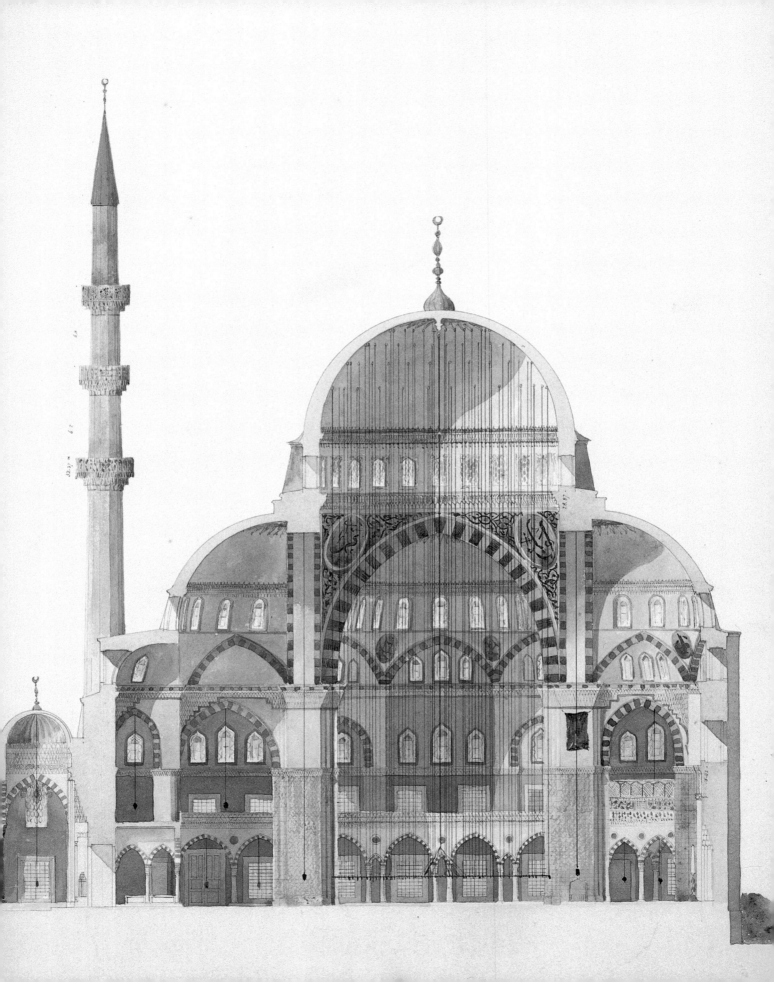

Science, Art and Design

The Ottoman Empire provided, as it were, a storehouse of raw materials for the minds of architects, designers, engineers and proto-scientists to use when they wished to go beyond the bounds of their own native traditions. There was to be found a never-failing source of design ideas, opportunities for archaeology and close observation of the natural world. Then there were not such rigid barriers between disciplines. Indeed, some artists were able to combine all three occupations, a feat possible and even normal at that date, before the twentieth-century demand for intense and exclusive scientific specialization.

Designers and design reformers of the nineteenth century sought inspiration in the study of lesser-known antiquities, but more particularly in the Islamic buildings found in the Ottoman Empire. Naturally, they made drawings of what they found and sought to publish them. Some leading architects, seized with the desire to synthesize a new style for the modern age, subjected the buildings of Turkey, Egypt and Syria to minute scrutiny. The study of Islamic art promised a fertile source of fresh ideas in pattern and design, which in northern Europe were apparently languishing in the grip of a stale tradition of enfeebled Neo-classicism.

Rulers as diverse as Napoleon, Sultan Abdülmecid of Turkey and Muhammad Ali, Viceroy of Egypt, employed artists and architects who were also draughtsmen and engineers, to design, build, repair and record. These absolute rulers all desired to modernize their domains and legitimize their rule. Although Napoleon was soon removed from Egypt, the particular kind of scientific scrutiny that he had initiated there continued. Some of the freelance architects inevitably became proto-archaeologists in depicting (and sometimes in removing) the remains of earlier civilizations within the empire. They also recorded the way of life of those modern people who dwelt among the remains.

Early scientists included those proto-biologists, the naturalists, who were trying to record the exotic fauna of Africa and Asia. All these polymaths, non-specialists though they defiantly were, observed the essential condition of modern science. That is: even before experiment can begin, methods of accurate observation and description must be in place. Until the invention of photography (and in many cases, even after that), drawing and painting were the primary means of visual record.

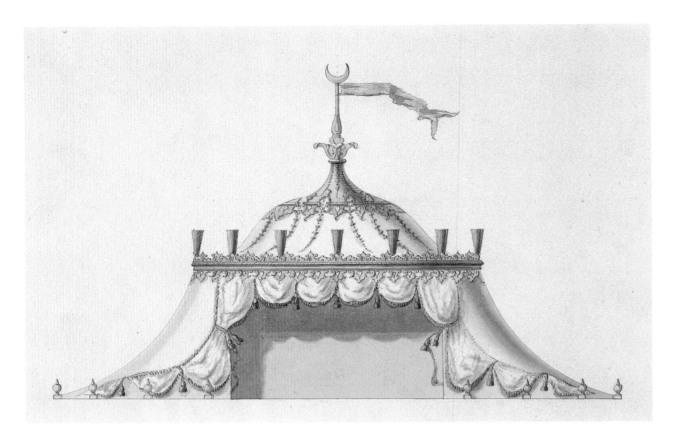

Design for a Turkish Tent

*c.*1760
Henry Keene (1726–1776)
Pen and ink and watercolour
V&A: E.916–1921

The ancestors of the Ottomans were Turkish nomads who lived in elaborate tents, and the Ottoman armies were famous for their pavilions, the 'stately tent of war', used as barracks even inside the circuit of stone walls of their fortresses. The early Sultans, frequently at war or out hunting with their courtiers, were accommodated in the most splendid and luxurious tents. In the middle of the eighteenth century some British landowners commissioned designs for 'Turkish Tents' to adorn picturesque landscapes, as a temporary or permanent feature. This design by the architect Henry Keene was used about 1760 by The Hon. Charles Hamilton at Painshill Park, Surrey. It was part of a sequence of exotic structures that Hamilton commissioned for his estate, which included a Gothic Temple, a Chinese Bridge, a Ruined Abbey, a Grotto, a Gothic Tower and a water wheel.

 Although built merely for pleasure, the Painshill Tent did have some ingenious practical features to combat the British climate. It had a permanent brick floor, oval in shape, and two-thirds of the walls were made of brick, plastered and painted. On top was an elaborate, wooden, lead-covered dome, and to this structure swathes of painted canvas were attached and secured with guy ropes, so that from a distance it looked very tent-like. There is some dispute as to whether the painted canvas was removed for the winter. The basic structure stood for a long time after the estate was sold in 1773, but it eventually disappeared about 1870. In 1995, however, the site was excavated and the tent carefully rebuilt by the Painshill Park Trust, using this design by Keene. It still commands the best view of the surrounding parkland. It may have even inspired the construction of similar picturesque tents in other countries, like the famous Turkish tents made of painted sheet copper at Drottningholm in Sweden.

Şehzade Camii, Istanbul

*c.*1819
Lewis Vulliamy (1791–1871)
Pencil
V&A: SD1161

The Şehzade Camii (Prince's Mosque) was built by the most famous Ottoman architect, Sinan, for Sultan Süleyman in the years 1544–8. This drawing is from a group of nine drawings of mosques in Istanbul and Bursa. The sketches are unusual for their time, since they have very accurate detail and perspective, yet appear rather ethereal. Another unusual feature is that there is a row of neatly spaced pinholes along the edges of the drawing, as if the paper were gripped and located in some kind of holder. The speculation is that they were done with the newly invented patent graphic telescope, or a similar drawing aid, perhaps a *camera lucida,* a device based on a lens system and viewer for tracing a faint outline from nature.

The drawings were made by Lewis Vulliamy, a British architect who had been articled to Sir Robert Smirke. Vulliamy had been awarded the Royal Academy's travelling studentship in 1818, and he went abroad for four years, mainly to Italy, but also to Greece and Turkey. On his return he set up an architectural practice, working in a variety of historical revival styles; his pupils included Owen Jones (see p.72). Vulliamy became a conventional architect, building houses and villas in the current restrained classical manner, and there is no evidence that he incorporated any Islamic ideas into his work. Nevertheless, unconventionally, he did draw this delicate series of mosques, including lesser-known ones, and he seems to have used the latest scientific instrument in order to do so. It is very possible that his pupil Owen Jones heard about Islamic architecture from his master, and about a scientific way of proto-photographic recording of design, with profound consequences for British design later in the century.

The Yeni Valide Camii in Istanbul

*c.*1832
Owen Jones (1809–1874) or Jules Goury (1803–1834)
Pencil, pen and ink and watercolour
V&A: 8271C

The Yeni Valide Camii, more widely known as the Yeni Cami or New Mosque, is located on the southern bank of the Golden Horn. Begun in 1597 by order of Safiye Sultan, the mother of Mehmet III, and designed by Davut Ağa, it was completed more than fifty years later by Turhan Hatice Sultan, the mother of Mehmet IV. ('Valide' means 'mother of the reigning Sultan'.)

This superb drawing of the mosque is an excellent example of the technique taught at the Ecole des Beaux-Arts, which Jules Goury attended as an architectural student in Paris. However, it is now very difficult to distinguish the early drawings of Owen Jones from those of his friend Goury, because they often seem to have worked on the same drawing together. Another unusual touch is that this drawing is inscribed with its title correctly in Turkish, phonetically rendered as *Ieni Jami Stamboulda*, that is, the Yeni Cami in Istanbul.

The architect and designer Owen Jones (possibly inspired by his master Lewis Vulliamy) used his Royal Academy scholarship to travel to Greece, Turkey and Egypt. In Athens he had met the young French architect Jules Goury, and

subsequently they travelled and drew together. Fired with enthusiasm by the marvellous array of polychrome architecture in Egypt and Turkey, they then went on to Spain, where they studied the Alhambra in Granada, and prepared their drawings for eventual publication as *Plans, Details, Elevations and Sections of the Alhambra* (1842–6).

After Goury died tragically young in 1834, Jones returned to England, determined to publish their work and to promote the use of Islamic and non-classical principles of design, colouring and ornamentation in a synthesis of a new style for the nineteenth century. Jones became for a time the most influential design theorist in Britain, especially since his work on the colouring and decoration of the Great Exhibition building ('The Crystal Palace'), when moved to Sydenham, made his ideas widely known. There is no doubt that his early exposure to the marvellous intricacies of Ottoman and Mamluk architecture and his subsequent work on the Alhambra made him into a passionate and practical advocate for the inspiration of Islamic colour and pattern.

Vue de la porte et détails des boutiques de l'Okél de Qayd-Bey [View of the door and details of the booths in the Wikalah of Sultan Qayt-Bey]

*c.*1820
Pen and ink and watercolour
Pascal-Xavier Coste (1787–1879)
V&A: SD272.32

In the words of Sir Richard Burton, on his way to Mecca, 'The Wakalah, as the Caravanserai or Khan is called in Egypt, combines the offices of hotel, lodging-house, and store.' These imposing structures were built to encourage trade, to accommodate merchants and travellers and their goods, and to supply them with services and provisions. This example was built by Sultan Qayt-Bey in 1477, and is situated to the south of the district of Cairo called al-Azhar. Only the façade remains, and Coste's drawing is therefore a valuable record of the intricacy and elegance of its construction, combining elaborately carved panels with *ablaq* (contrasting or pied) decoration.

Coste was an architect and pioneer of the study of Islamic art. Born in Marseilles, and the designer of several important buildings in that city, he studied for a time at the Ecole des Beaux-Arts in Paris. His meticulous rendering of architectural detail in pencil and watercolour show him to have been a keen student, since his drawing style is typical of the best they taught there. He was employed in the years 1817–27 by the ruler of Egypt, Muhammad Ali, to design and oversee various constructions, including a palace and the Mahmudiyyah Canal. At the same time, fired by his obvious enthusiasm for Mamluk architecture, he compiled this magnificent volume of architectural drawings, which was the first to show in fine and precise detail the Islamic buildings of Cairo.

Coste made the drawings in Cairo between 1818 and 1822, but did not publish them until 1837, as *Architecture arabe; ou, monuments du Kaire*, due to protracted negotiations with the Egyptologist Robert Hay. Hay had purchased them from Coste with exclusive rights of publication, but then failed to meet the deadline imposed by the artist.

Vue Générale de la Grande Nef en regardant l'Orient
[View of the nave of Aya Sofya, looking east]

Plate 4 from *Aya Sofia* [*sic*] *Constantinople*, published by
P. & D. Colnaghi, London

1852
Gaspard Fossati (1809–1883)
Lithograph, with two tint-stones, coloured by hand
V&A: SP270.2

Hagia Sophia ('Holy Wisdom') was the greatest
church of the Byzantine Empire. The Emperor
Justinian built it in the years 532–7, and
although it suffered damage by earthquake
immediately after it was built, and on several
occasions since, it has stood to this day. Until
St Peter's in Rome was rebuilt about a thousand
years later, it had the largest dome of any
church in Christendom. After the conquest of
Constantinople in 1453, Sultan Mehmet II
immediately converted it into the mosque of Aya
Sofya. The frescos and mosaics were plastered
over, the altar thrown down, and all instruments
of Christian worship removed. Minarets, a new
pulpit (*minbar*) for the imam and a *mihrab* (a
marker indicating the direction of Mecca) were
introduced, but little else, since a mosque is pri-
marily a place for the assembly of believers.

The structure was little changed until earth-
quake damage in the late 1840s persuaded the
Sultan to commission the Fossati brothers,
Gaspard and Giuseppe, to repair the building.
They were architects and draughtsmen who had
worked previously in St Petersburg. Extensive
repairs were carried out on the dome, and then
Gaspard published a set of lithographs showing
internal and external views of the church, as a
kind of advertisement. This had the partly
unforeseen effect of reviving interest in
Byzantine architecture. Hagia Sophia remained
in use as a mosque until 1935, when Kemal
Atatürk, President of the Turkish Republic,
decreed that it should cease to be a place of
worship and should be reopened as a museum.
The surviving mosaics and frescos were exposed
and conserved, revealing something of the early
splendour of the interior.

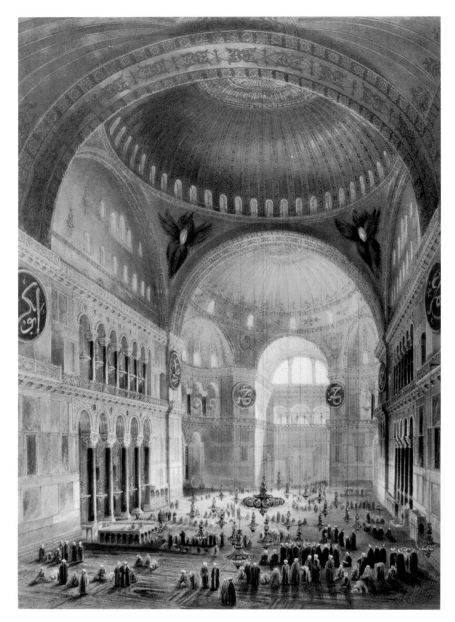

The Great Khan, Damascus

1866
Richard Phené Spiers FRIBA FSA (1838–1916)
Watercolour over pencil
V&A: SD997

In 1751 the Governor of Damascus, Asad Pasha al-Azam, commissioned the construction of this 'khan', or secure place for caravans of merchants to stay, store and sell their goods. It was completed in 1753. As in medieval Europe, there was no basic difference in architectural style between large secular and religious buildings, so that this khan shares with mosques of this period the same kind of graceful domes, galleries, columns and arches. The two-storey structure is square in plan, with a large central court surmounted by nine domes. It contains a total of 80 rooms distributed on two levels around the courtyard. A monumental doorway allows access to and from the market. The alternate colours of the bands of stone are good examples of the polychrome or multicoloured architecture, common in Syria and Egypt, that was much admired and studied by progressive architects in northern Europe in the nineteenth century. By the 1980s this khan was being used as a storage space in the heart of a busy commercial area in Damascus by a large number of shop owners. The Syrian Department of Museums and Antiquities intervened, and a complete restoration of the khan was carried out.

In the search for ideas for a new building style many British architects had studied architecture outside Europe. These traditional forms were also threatened with obliteration by 'the march of progress', and drawings had to be made to record them in case they disappeared. Spiers was an architect better known for his teaching and writing on the subject than as a practitioner. In 1865–6 he toured the Middle East on a travelling scholarship from the Royal Academy. On his return he exhibited several pictures with eastern subjects at the Royal Academy, of which this was probably one. His aim was to encourage British architects to adopt or be inspired by the different traditions of architectural practice to be found within Islam. He was master of the Royal Academy School of Architecture from 1870 to 1905 and also taught at the Royal Institute of British Architects.

Interior of the House of the Mufti Shaykh al Mahdi, Cairo

1869
Frank Dillon RI (1823–1909)
Gouache on paper
V&A: 583–1900

At the beginning of the nineteenth century an increasing number of British architects began to study architecture outside Europe, as they searched for ideas for a new building style. They looked beyond the classical forms sanctioned by ancient Greece and Rome that had been generally employed for the previous 150 years. Dillon, in the course of studying such buildings as the grand Mamluk houses of Cairo, realized that they were threatened with obliteration by 'the march of progress', and that drawings had to be made to record them before they were destroyed. In his desire to preserve the domestic architecture of Cairo, particularly the interiors, Dillon painted accurate pictures of them as a record and as a kind of advertisement for his campaign to save them. He included their inhabitants in appropriate costume, to give scale and to make them more appealing.

The old houses, like their medieval counterparts in European cities, were often swept away by 'improvements'. One historical quirk made large empty houses in Cairo particularly vulnerable. Before the introduction of modern banking systems and paper money, it had been traditional to conceal one's wealth in secret places built into the fabric of the houses. Therefore there was a real possibility that there might be large sums of money still hidden if an owner had died suddenly without revealing to his heirs where the coins had been placed. In the larger houses there were often several hiding places, and looters would enter and demolish unoccupied houses indiscriminately in their search for silver and gold coins.

Frank Dillon was part of the circle that had surrounded Owen Jones. Like many of these design reformers, he wished to encourage interest in the decorative art and architecture of other cultures. In the 1880s and '90s he was actively concerned with efforts to preserve the Islamic monuments of Cairo, but he also travelled in Portugal, Spain and Morocco, as well as Japan, where he studied and painted traditional Japanese interiors. In the 1870s he used artefacts he had brought back from Cairo to create an 'Arab studio' in his Kensington house.

A Tomb in Lycia, Turkey

c.1812
John Peter Gandy (afterwards Deering) RA (1787–1850)
Watercolour over pencil
V&A: SD412

Gandy was an architect and draughtsman. In the years 1811–13 he took part in an expedition led by Sir William Gell, on behalf of the Society of Dilettanti, that investigated and drew antiquities in Greece and south-west Turkey, including Lycia. A large number of drawings from that trip are in the collections of the Royal Institute of British Architects (RIBA). The watercolour shown here may have been done after the trip, but it has not yet been possible to identify the tomb, despite the distinctive relief on the side. Some commentators believe it may have been destroyed, or that Gandy may have even concocted the tomb from various sources, and placed it in a suitably picturesque setting.

However, the background of cliffs and the towering reeds by the shore of a freshwater lake are reminiscent of fertile places and archaeological sites like modern Dalyan and Caunos. The abundance of small details such as the brown pebbles on the roof of the tomb, the remaining cut stems of the reeds near the feet of the Turk with the billhook, and the almost readable carved inscription on the tomb imply that if Gandy did invent or conflate real things in his imagination, he was extremely good at it. From this drawing it would be perfectly possible to build a replica of the tomb. In a sense, in some cases this was done, for details of sculpture and construction were borrowed from Lycian monuments and freely used in British Neo-classical architecture.

A Hall in an Assyrian Temple or Palace, Restored from Actual Remains, and from Fragments Discovered in the Ruins

*c.*1849
Sir Austen Henry Layard GCB (1817–1894)
Pen and ink and watercolour
V&A: SD559

Using his skill as a painter, Layard attempted to reconstruct imaginatively on paper some of the extensive ruins of a palace he had excavated at Nimrud. Here can be seen the strange man-headed winged bulls in position. This image is now known to represent the principal ceremonial room in the palace of King Ashurnasipal II in the ninth century BCE. This watercolour was reproduced as a lithograph in Layard's book, *The Monuments of Nineveh*, of 1849. Some details of the reconstruction are inaccurate, yet as a whole it gives a vivid idea of the splendour and might of the Kingdom of Assyria, as described in the Bible.

Indeed, Layard's discoveries, which confirmed some of the biblical accounts of Assyria, not least the destruction of Nineveh and Babylon, caused great enthusiasm among Christians in Britain and America. The finding of the remains of this great pre-classical civilization also inspired poets and artists. For example, Dante Gabriel Rossetti wrote his poem 'The Burden of Nineveh' in 1856 after a visit to the British Museum to see the winged bulls. Also in 1856, the Great Exhibition building was moved to Sydenham in south London. It now included among its architectural displays an 'Assyrian Court' in which reproductions, including full-scale winged bulls appropriately painted, had been constructed, using Layard as an adviser.

Raft Conveying the Winged Bull to Baghdad

*c.*1850
Frederick Charles Cooper (1817–after 1868)
Watercolour over pencil
V&A: SD257

Visitors to the British Museum have sometimes wondered how the massive ancient Assyrian winged bulls now on display there were actually transported from Iraq in the 1840s. This watercolour shows one stage of their journey, on a raft down the Tigris. The Trustees of the British Museum had funded Austen Henry Layard to excavate the ruins of Nineveh and Babylon; and part of the plan was to bring back examples of the antiquities he had found.

Layard describes the removal of the winged bulls from the site of the mound of Nimrud in *Nineveh and Its Remains* (1849), from where they had lain for approximately the last 2,730 years. They were carefully loaded on to rafts, made in the traditional way with hundreds of inflated goat and sheep skins supporting a wooden superstructure. The top of the head of the sculpture can be seen on the right of the picture, emerging from its tarpaulin cover. Layard (who had learnt Arabic and Persian) recruited the crew locally, as he had done with his workforce. In

April 1847 he sent them floating with the current, off on a 600-mile journey down the River Tigris to Basra, where ships of the British Navy were waiting to take the bulls the next 12,000 miles to England.

Although the artist Cooper was not present on this occasion, he subsequently witnessed similar events, and would have been able to reconstruct the scene, perhaps using a sketch by Layard, who was also a talented artist. Cooper was a painter in oils and watercolours from Nottingham whose previous works had been mainly of genre and literary subjects. In 1849 he was selected by the Trustees of the British Museum to accompany Layard to Nineveh, and returned to England after visiting Kurdistan with him in July 1850. He exhibited at the Royal Academy and elsewhere in London in the years 1844–68 (including views of Nineveh). Cooper painted a diorama of Nineveh, presented at the Gothic Hall, Lower Grosvenor Street, with an accompanying lecture, in 1851.

The Winged Bulls in the Crystal Palace at Sydenham

1854
Philip Henry Delamotte (1821–1889)
Salted paper print from glass negative
V&A: 39.308

Delamotte was an illustrator and pioneering photographer, whose manual *The Practice of Photography* was published in 1853. One of his most famous commissions was the photography (undertaken weekly from 1851 to 1854) of the reconstruction of the Crystal Palace. He subsequently published his work in *Photographic Views of the Progress of the Crystal Palace, Sydenham* (1855). He probably obtained the commission because he had provided illustrations to a catalogue of an exhibition at the Royal Society of Arts in 1850, whose members included Prince Albert and Sir Henry Cole, the promoters of the Great Exhibition.

Here he illustrates a detail of the Assyrian Court, a full-scale reconstruction based on Layard's excavations and advice. The literalness of the photograph, the slightly sinister absence of an audience and modern unfamiliarity with the style of Victorian reconstruction techniques now give the image a surreal tinge.

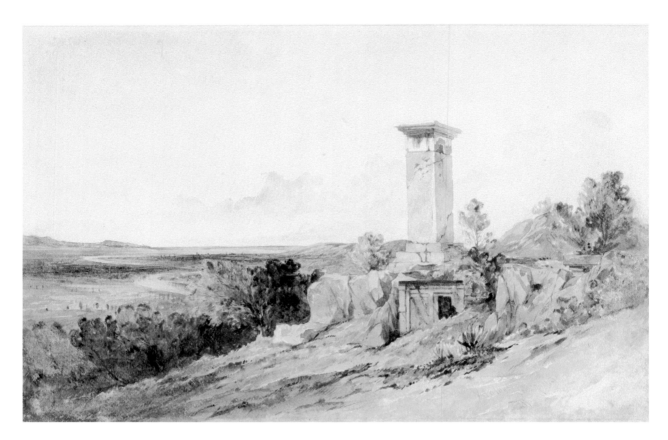

Xanthus

1843
Harry John Johnson RI (1826–1884)
Watercolour over pencil
V&A: SD527

The search for novel subjects spurred artists to visit ever more remote places. The archaeological discoveries of Sir Charles Fellows in what had been ancient Lycia (now part of south-western Turkey) revealed the cities, buildings and tombs of an ancient non-Greek people, about whom little was known, although the Lycians appear briefly in various Greek histories. In the mid-nineteenth century some parts of the Anatolian coast were accessible only by boat. Fellows mapped the sites of the cities of Xanthus, Pinara, Patara, Tlos, Myra and Olympus, and collected a large number of Lycian antiquities. With the aid of the British Navy (and some Government funding) and a large contingent of carpenters, masons and seamen, he shipped them back to England, where they were displayed in the British Museum. The most famous monuments still on display there from Xanthus are the reliefs from the Harpy Tomb and the Nereid monument.

The painter William Müller and his pupil Harry Johnson joined his expedition at Xanthus, and they made a series of landscape views of various Lycian sites, including Pinara, Tlos and Telmessus (modern Fethiye). The site of Xanthus is remarkable for its strange pillar tomb, and Johnson shows it here, and the Xanthus River behind (now called the Esen Çay). Johnson, a landscape painter in oils and watercolours from Birmingham, used the contemporary techniques of British watercolour landscape painting, taught to him by Müller, on a very un-British subject. The freedom and realism with which he painted the scene (today, still much as he showed it) look forward to the development of realism in landscape watercolours that became usual later on in the century.

Vue de la colonne de Pompée à Alexandrie

1798
Baron Dominique Vivant Denon (1747–1825)
Watercolour over pencil
V&A: SD314

Here Denon has depicted an incident in Napoleon's campaign in Egypt. The two figures on the right in the foreground are probably Napoleon and Denon himself. The kite-flying is a method of getting a thin line over the capital of the column in order to pull up a rope, and then a harness, to haul up a soldier, who would then fly the French colours from the top. The British did exactly the same with their own flags after the defeat of the French forces, and a print exists depicting them doing just that. The kite was not being used to measure the height of the column, since it would have been much simpler and more accurate for Napoleon's surveyors to do this by basic trigonometry. The red granite column was 22 metres high, crowned with an immense capital and visible from a great distance. It was built in CE 300 in honour of the Emperor Diocletian, and in medieval times was mistakenly believed to mark the site of a temple of Pompey.

Napoleon's rapid invasion of Egypt in 1798 had far-reaching consequences, even if it was short-lived. Although various travellers had already brought back descriptions and pictures of Egypt ancient and modern, Napoleon commissioned the first large-scale systematic attempt to record that nation and its heritage. He recruited a large group of savants – scholars and experts in a variety of fields – who intended to describe every aspect of Egyptian life, its monuments and its culture. They used as their model, both in the scope of their enquiries and in their forms of illustration, the great *Encyclopédie* edited by Denis Diderot. Their findings were published in the vast multi-volume *Description de L'Egypte* (1809–22), but long before its appearance renewed interest in Egypt and its antiquities had swept thorough Europe. Denon himself rushed out his own account of the country in his *Voyage dans la Basse et la Haute Égypte* (1802), illustrated with his drawings. Denon was an artist, diplomat, author and antiquary who became a leading Egyptologist. He was appointed Director-General of Museums in 1804, becoming the first director of the Louvre.

Rat d'Egypte apellé en Arabe Gérbouh
[Jerboa or desert rat]

Jean-Baptiste Adanson (1732–1804)
Watercolour over pencil
V&A: SD10

Jerboas, rodents equipped with powerful hind legs and very long tails for balance, are capable of leaping large distances to escape predators. They are nocturnal desert dwellers, common in Egypt, thriving in arid conditions and feeding on plant material. Here, this animal, possibly a portrait of a pet (they are said to be shy but easily tamed), is shown eating a date, holding the fruit in its tiny front paws. The name jerboa is said to derive from Arabic words meaning 'meaty thighs', and for a mouse-like creature they are certainly big. Their burrows are deep and include a sleeping chamber with a nest made of camel's hair or shredded vegetation.

Jean-Baptiste Adanson was a diplomat, antiquarian and draughtsman, and brother of the naturalist Michel Adanson. He was the official French interpreter at various cities in Egypt and Syria, and became French consul in Egypt from 1775 until 1785. He compiled a large collection of his drawings of natural history, antiquities and views, yet a proposal in 1795 by a committee of the Convention Nationale in Paris to publish this material was never realized. In some ways Jean-Baptiste anticipated Napoleon's project of recording modern and ancient Egypt, which was finally published under the title of *Description de L'Egypte* in the early years of the nineteenth century.

Study of a Hippopotamus

1825
Henry Salt FRS FLS (1780–1827)
Pencil, pen and ink
V&A: SD909

The hippopotamus was an object of much interest to early natural historians and the curious public alike. Many legends grew up about this huge and remarkable Nile-dwelling beast, especially since some biblical scholars said that it must have been the massive animal called the 'Behemoth' as described in the book of Job, but others disagreed (and some still do). Hippopotami (and crocodiles) were still to be found in the Delta region of the Nile in the early nineteenth century. In a letter dated 26 September 1818 Salt recorded the hunting of a hippopotamus near Damietta (modern Dumyat) and continued: 'I have seen the skin, and got a pretty correct drawing of it.'

Salt was a diplomat and a collector of antiquities. He was also an artist who had received training in drawing and portrait-painting from established artists, including J. Glover, J. Farington and J. Hoppner. He was later to use his skills to draw ancient Egyptian antiquities. After government missions in India, Ceylon, Abyssinia and Egypt, he was appointed British Consul-General in Egypt in 1815, and during his term of office (1816–27) financed several excavations, including those of G.B. Belzoni. Salt formed three large collections of antiquities, most of which were eventually acquired by the British Museum and the Louvre.

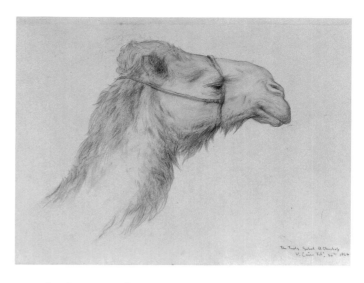

Head of a Camel

1864
Elijah Walton (1832–1880)
Black chalk on pale green paper
V&A: SD1175

'The sight of the camel made me pine again for Asia Minor', sighed Lord Byron, recording in his journal a visit to the Exeter Change menagerie in the Strand in London. This enigmatic animal has been the symbol only of the desert lands to many in northern Europe, although Byron knew better. In fact, it was a common sight in most of the Ottoman dominions. As well as being the main beast of burden in caravans, nomads relied on camels to transport their goods and tents between their summer and winter pastures. This is a portrait of the single-humped dromedary, whereas the larger two-humped Bactrian camel was native to Central Asia.

Elijah Walton had begun as a painter of romantic alpine landscapes, but after visits to Egypt in the early 1860s he developed a special interest in the camel. As well as making many drawings and watercolours of Egypt's people and landscape, he spent time in 1863–4 in a Bedouin encampment near Cairo, studying the camel's habits and anatomy. The following year he published his drawings in *The Camel: Its Anatomy, Proportion and Paces*, comparable in its detail to George Stubbs's *Anatomy of the Horse*, of almost exactly a century earlier. Here he shows in affectionate detail the furry head of a young camel with its long eyelashes, which protect the eyes by keeping out the wind-blown sand.

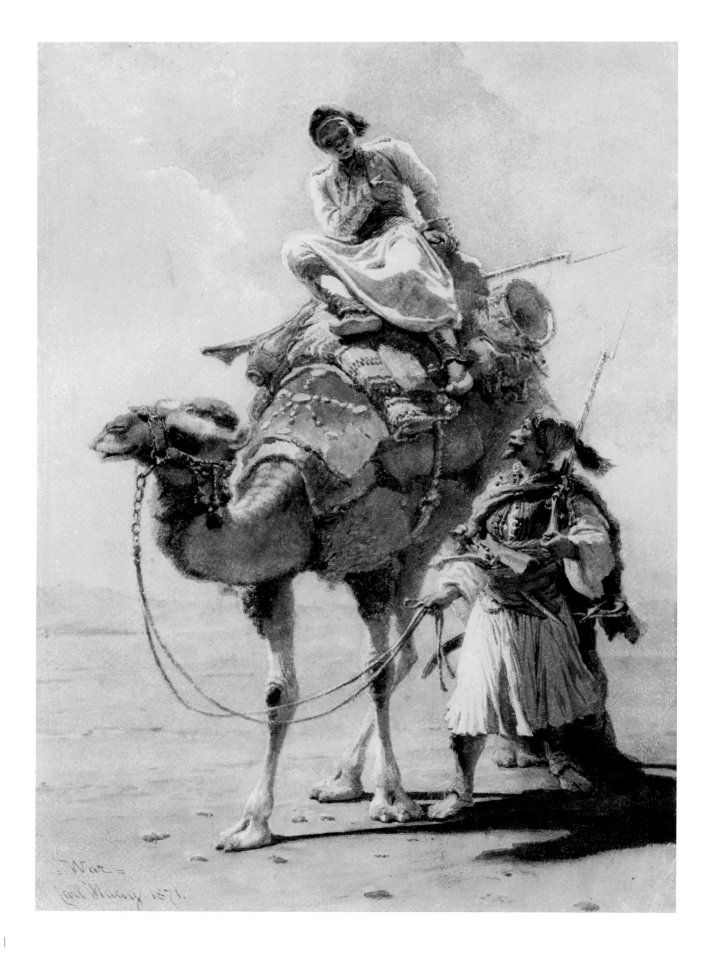

War

The source of empire is always war and its technology. The Ottomans were followers of the fourteenth-century ruler Gazi ('Fighter for the Faith') Osman. His subjects first came to the attention of the Christian West as they advanced through Asia Minor as a fierce warrior band. Yet the real power of the Ottomans lay in their ability to organize, invent and adapt the latest technologies and strategies. They posed a real threat because they were believed to combine the martial enthusiasm of a young nation with a sophisticated grasp of the art of war. Their incursions into Europe coincided with the development of printmaking and printing there in the fifteenth century, so images of this emergent state became increasingly frequent. The continuous struggle to expand the Ottoman Empire, after it had finally conquered the disorganized and weakened Byzantine Empire, and then attacked the Holy Roman Empire in Central Europe, was thus well documented in words and images. The Turks were no less able to organize and govern these conquered lands, and prepared to expand their conquests with a series of wars and alliances, right up to the gates of Vienna in the late seventeenth century. At the beginning of the eighteenth century expansion had ceased, and wars had to be fought to preserve the conquered territories, particularly against Russia, another rising empire.

The ill-fated alliance with the Central Powers in the First World War meant that the Ottoman state virtually collapsed (as all empires seem to do in the end) with Germany's war effort in 1918. So the Ottoman Sultanate ended, as it had begun, in battle with another declining empire, in this case the British one and its allies. Ironically, Turkey was finally changed into a modern secular republic mainly by the efforts of a successful general, Kemal Atatürk.

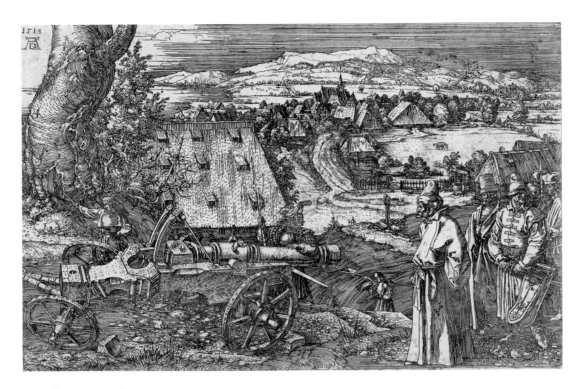

Landscape with Cannon

1518
Albrecht Dürer (1471–1528)
Etching on iron
V&A: E.579-1940

Dürer's prints often have mysterious elements. This unsettling image of a party of armed Ottomans in the heart of Germany, grimly inspecting a cannon (decorated with the arms of Nuremberg), is no exception. Various explanations have been put forward, but Dürer's exact motives for this composition are not known. At the date of this print, however, after treaties signed with the Venetians and the Hungarians in 1503, the Ottomans had disengaged from further invasion of Europe. An uneasy peace lasted in the West until 1521, while the Ottomans were fighting another enemy, the Mamluks, and occupying Syria and Egypt. So it is possible, although unlikely, that a party of Ottomans could have visited Bavaria in 1517–18, where the artist has set this scene.

The Ottoman party is led by a Turk, probably a *Topçubaşı*, or commander of artillery, attended by his allies and assistants from occupied Hungary and Wallachia, surveying the armaments of the opposition. They are being shown, perhaps deliberately, an old-fashioned cannon, already a museum piece. Meanwhile, in the same year as this print, Dürer's patron, the Emperor

Maximilian I, was again urging a crusade against the Turks, and the imperial foundry near Innsbruck was producing cannon much more advanced than the one depicted here.

Sultan Selim in his turn had enticed European cannon-founders into his service, and so the Turkish arsenals were also producing smaller and more efficient cannon of French design. These were much more mobile and dangerous in the field than the huge unwieldy siege pieces (the biggest designed and cast by a renegade Hungarian) that the Turks had used to breach the walls of Constantinople in 1453. Their decisive success in Syria and Egypt was partly due to the skilled use of these new guns. Perhaps Dürer was illustrating the danger posed to Christendom by the Turks' keen interest in artillery. The Ottoman frontier in 1518 was not far from either Vienna or Venice, so this print could even be an early illustration of an episode in an arms' race.

The etching plate from which this image was printed was itself a recent technological innovation. This printing method was quicker and simpler (but cruder in effect) than Dürer's usual method of fine engraving on copper. Printing plates etched on iron were derived from the practice of decorating steel armour by chemically etching patterns drawn through a wax resist.

The Turkish Family

1497
Albrecht Dürer (1471–1528)
Engraving
V&A: 26794

This early engraving by Dürer cannot be based
on direct observation. He might have seen
Turkish merchants in Venice, yet here he seems
to have pictured the Turks as he and most people
in late fifteenth-century Germany imagined
them to be. He shows a turbaned warrior,
armed with a bow (but holding the arrows,
without the distinctive Turkish *okluk* or quiver),
and a Turkish peasant woman and child, which
almost certainly he would not have seen. The
woman is shown barefoot, wearing a man's
turban, and is dressed in little more than a cloak.
These cannot be portraits, but are possibly based
on travellers' descriptions of nomadic Turcomans
in the heart of Turkey. There the women often
went unveiled, unlike women in the towns.
Perhaps Dürer is depicting what he thought was
the unfailing source of Ottoman military might,
the fierce warrior and his hardy wife and family.

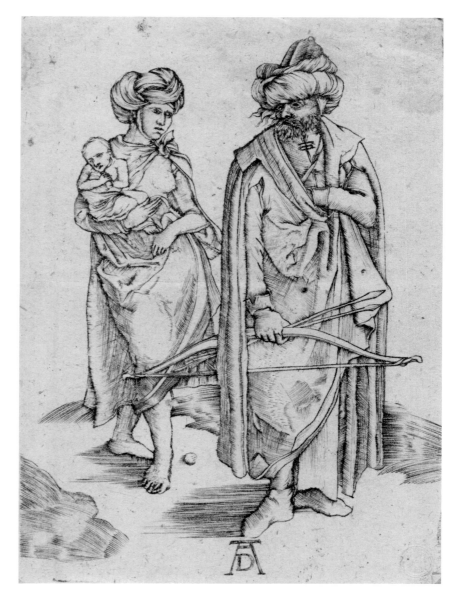

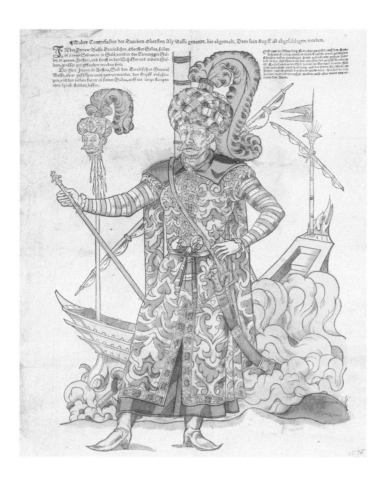

'Conterfactur des Turcken Obersten Aly Bassa genandt/ hie abgemalt/ Dem sein Kopffist . . . '
['True likeness of the beheaded Turkish officer Ali Bassa']

*c.*1572
Anonymous
Woodcut coloured by hand on laid paper
V&A: E.912–2003

This fascinating and rare propaganda print was published in Germany probably shortly after the allied Christian naval victory over the Turks at the Battle of Lepanto in 1571. Ali Pasha, the defeated Turkish naval commander, is shown full length, wearing a kaftan of costly woven, figured silks. His robes, turban and long feathery head-dress denote his high rank. Although he is shown alive, in the background is a detail of his head on the end of a pole. Behind Ali Pasha is the Turkish flagship on which he was wounded and subsequently beheaded. The text in German dwells on the death of Ali, the huge amount of gold seized from his ships and the providence of God. Although the closely fought battle was indeed a defeat for the Turks, the remaining commander, Uluj Ali, returned safely to Istanbul, and within a short time they rebuilt their fleet. Two years later, a naval expedition led by Uluj Ali occupied Cyprus, and in 1574 Koca Sinan Pasha took Tunis from the Spaniards.

Prints such as this would have been made and sold in large numbers. They may have served as a form of proclamation pasted up in a public place. They were designed for wide distribution and were cheap. The messages were simple and direct. The vast majority of such prints were bought casually and treated carelessly, and very few would have survived. This print has been folded at some stage and was perhaps inserted in a book, which may have ensured its survival. The back of the sheet appears to have been used for doing some hasty sums.

Cavalry Engagement against Turks,
with a Distant View of a Town

c.1710
Jan Pieter van Bredael (1683–1735)
Oil on oak panel
V&A: 547–1870

At the beginning of the eighteenth century
Sultan Ahmed III was still trying to extend the
Ottoman Empire westwards. However, although
he did not realize it, the failure to take Vienna
in the famous siege of 1683 had represented the
limit of the empire's military expansion. The
Sultan declared war against Austria once more
in 1715, and in the following years his armies
were defeated again by the superior leadership of
Prince Eugene of Savoy in a number of battles.
Peace was signed in 1718 with the Treaty of
Passarowitch, and Hungary was thereby liberat-
ed from Ottoman rule. The Ottomans, although
no longer led into battle by the Sultan in person,
had stuck to their once-formidable traditional
methods of warfare. These had become progres-

sively less effective against forces led by modern
generals such as Prince Eugene.

Jan Pieter van Bredael was born in Antwerp,
but he moved to Prague in 1706 to work for
Prince Eugene, for whom he painted battle and
hunting scenes. He finally settled in Vienna,
where he specialized in cavalry scenes such as
this one. Successful generals and other partici-
pants frequently commissioned dramatized
pictures of their victories, and paintings of battle
scenes had been popular from ancient times. For
example, an Athenian painter made a depiction
of the Battle of Marathon that was on show
in Athens in the fifth century BCE.

'L'Insurrection de l'Institut Amphibie'
[The Pursuit of Knowledge]

From a set of seven plates entitled *Egyptian Sketches*

1799
James Gillray (1756/7–1815)
Etching, coloured by hand
V&A: SP294.2

Gillray was perhaps the most talented, ingenious and certainly the most savage British caricaturist before the twentieth century. He combined expert knowledge of his victims with gleeful cruelty in depicting their follies, mingling gross exaggeration with telling details. The presumption of the French enemy, in trying to conquer Egypt, supposedly to bring the benefits of French civilization, was a natural target for him. When Napoleon invaded Egypt in 1798, he brought with him a collection of savants, who created the Institut d'Egypte. They were intellectuals who thought they would record Egypt and teach the Egyptians modern ways, that is, ultimately reduce them to a French colony. Two of these savants are satirized here, shown with a tract entitled 'Sur l'education du crocodile', which has proved less than useful to its authors.

Naturally enough, the Egyptians were not deceived as to the real colonialist motives behind this expedition, and resisted fiercely. They were aided by the British, particularly Nelson, who burnt the French Fleet at Aboukir. In this print, Egyptian resistance is neatly symbolized by the crocodile. Although he was not interested in anatomical accuracy here, Gillray did not exaggerate the ferocity of these large, intelligent and very dangerous creatures that were still to be found along the length of the Nile and the Delta at this date.

The Valley of the Shadow of Death

1855
Roger Fenton (1819–1869)
Salted paper print from glass negative
V&A: 64.858

The Ottoman Empire once extended to the Crimea, and this strange and rather empty image depicts a very significant place, near Sapun-Gora outside the city of Sebastopol. The Crimean War (1854–6) was caused nominally by a complex dispute about the jurisdiction of the holy places in Ottoman-held Jerusalem. It was fought out between the Russians and an alliance of the Ottoman Empire, Britain and France.

In this photograph, the rough and stony track, running between low parched hills, is actually the place where occurred that feat of mistaken heroism, the Charge of the Light Brigade. This incident, typical of the military incompetence at a senior level in the Crimean War, was immortalized by Alfred, Lord Tennyson in his poem 'The Charge of the Light Brigade' (1854), and caught the imagination of the British public. The barren path is scattered with cannon balls, fired by the Russians at the suicidal British cavalry charge into the mouths of the guns. Somehow, to modern eyes, the enforced stillness of Fenton's photograph is more chilling than a painter's reconstruction of the heat of battle would have been. Of the 637 men in the charge, 247 were said to have been killed or wounded. Yet, during the course of the war, vastly more soldiers died of disease or badly treated wounds than perished in battle.

Roger Fenton was a lawyer who became a painter and then a photographer about 1852. In that year he travelled to Russia and took photographs of Moscow, Kiev and St Petersburg. In 1854 he was approached by the publisher Thomas Agnew and commissioned to take semi-official pictures of the war, which was the first time the British Army had been active in Europe since the Napoleonic Wars. Owing to the long exposure times required, and the arduous conditions under which he took and processed his photographs, the images are mainly topographical views and portraits of the serving British Army. Despite these difficulties, Fenton produced up to 360 photographs of the war. In the title of this print he (and Tennyson in his poem) was referring to Psalm 23 in the Bible: 'Though I walk through the valley of the shadow of death, I shall fear no evil'.

War [SEE PAGE 86]

1871
Carl Haag RWS (1820–1915)
Watercolour
V&A: SD461

Haag was a prolific and successful painter in watercolours of narrative, genre and portrait subjects. He was born in Bavaria, and in 1847 came to London, where he developed an elaborate watercolour technique and a set of appreciative patrons that included Prince Albert and Queen Victoria. Haag continued to paint predominately eastern subjects for many years after his visit to Egypt, Palestine, Syria and Lebanon in the years 1858–60. This watercolour and its companion *Peace* are two such examples, painted not long before he returned to Egypt in 1873.

The wounded drummer-boy is borne back to camp on his camel, and the nearby battle is further indicated by the assorted weapons carried by the two soldiers. Haag may have intended to point a contrast between the young Nubian lad in his uniform of a *nizam*, or new-style regular soldier in the Egyptian army, and the older *Arnavut* (Albanian), many of whom had formerly been employed as irregular mercenaries. It is a very sanitized and sentimental view of war (complete with colourful costumes and scarcely any injuries), possible only before the horrors of mass warfare with modern weapons generally impinged itself on the consciousness of insular Britain. In the year that this was painted, the Franco-Prussian War of 1870–71 was taking place. Its reliance on railway timetables for mass troop movements and the transport of modern artillery foreshadowed the technological nature of all future wars.

The Retreat from Serbia [OPPOSITE TOP]

1916
Robert John Gibbings (1889–1958)
Colour woodcut
V&A: E.1832–1919

This print is based on a remarkable photograph taken by a war correspondent and published in the *Illustrated London News* on 15 January 1916. The Serbian commander-in-chief, Marshall Putnik, was heading the retreat from the Germans through Albania. His soldiers carried him in a sedan chair over the Bridge of the Viziers, which crossed a river, the White Drin. Gibbings's artist's eye was caught by the stark but beautiful lines of the stonework of the sixteenth-century Ottoman bridge. Its distinctive parabola form, without a parapet, was characteristic of many bridges built by Ottoman military engineers throughout Serbia, Albania and the rest of the empire. Few such bridges survive after the ravages of time, conflict and modernization, even within Turkey itself. The most famous example, a favourite subject for artists and printmakers, the bridge at Mostar in Bosnia-Herzegovina, was deliberately destroyed by shellfire in 1993, and rebuilt only recently.

The subtle hand-colouring of this woodcut enhances the melancholy nature of the subject. The image in the newspaper was striking enough, but the printmaker has made something even more haunting from this tragic episode of the First World War. Gibbings himself served in the army and was wounded at Gallipoli (Gelibolu in modern Turkey), but although he produced several prints of the buildings he had seen while abroad, he did not otherwise make images of the war. As subject matter for his early prints, Gibbings often used the silhouetted forms of architecture, since they were peculiarly suited to the hard-edge patterns rendered by the woodcut block.

The First Sight of Jerusalem, Nebi Samwil (No.2) [BELOW LEFT]

Published 1920
James McBey (1883–1959)
Etching and drypoint
V&A: SP395

The Ottoman Turks, having entered the First World War on the German side, had successfully repelled the Allied landings at Gallipoli in 1915, and destroyed a British expeditionary force at Kut-al-Amara in Iraq in 1916. Yet in November 1917 the British Expeditionary Force in Egypt and their allies, under the competent leadership of General Allenby, had advanced and out-flanked Jerusalem, defeating the depleted Ottoman forces in a series of battles. By 22 November Allenby's troops were dug in on the highest hill overlooking Jerusalem, about 5 kilo-metres away. This had been the traditionally accepted burial place of the prophet Samuel (*Nebi Samwil* in Arabic). After a series of fierce counter-attacks by the Turks, the Allies advanced again and took the surrender of Jerusalem on 9 December. In 1098 the Crusaders had had their first view of Jerusalem from the heights of Nebi Samwil and renamed it Montjoie ('Hill of Joy'). It naturally reverted to its old title when Saladin captured Jerusalem in 1187.

McBey drew the original of this image on the spot. He turned it into an etching, part of a set, which was finally published in 1920. The scene of the troops in a shallow trench under fire, with shell-bursts visible in the sky and in front of the trench, is the most dramatic of this series. To the left, at the summit of the hill, is an eighteenth-century mosque that was damaged in the fight-ing. The technique of etching and drypoint, with its effect of wiry lines and blurring of detail, proved appropriate to the subject of modern warfare. James McBey was a self-taught and successful painter, draughtsman and etcher. Until 1910 he worked in a bank in Aberdeen. He was appointed Official War Artist with the British Expeditionary Force in Egypt in 1917, and returned from the Holy Land with numerous drawings and watercolours, including portraits of General Allenby, the Emir Feisal and T.E. Lawrence, many now in the Imperial War Museum in London.

MOSQVE

Domus Alexandri Magni

Castelle noue

Ganophalo.

ANEVM MARE

Trade

Many anthropologists now believe that from the very beginnings of human society trade has been a major factor in the spread of ideas and civilization. A frequent phenomenon throughout history has been that trade often somehow continues even though the rulers of the trading states are at that moment theoretically enemies at war. The warrior class often unjustly despised merchants. In Britain, for example, this prejudice culminated in the fearful snobbery of Victorian England, where indulgence in 'trade' was not the mark of the gently born. Ownership and exploitation of land and tenants were acceptable, but the trading and manufacture of commodities were not. The injustice of this is seen in the prosperity of Britain (and therefore British society), which rose directly from sea-borne trading. The stupendous wealth of Venice, and therefore the financing of its culture, had risen from trade with Egypt, Turkey and Syria.

In 1581 Queen Elizabeth I had astutely granted the Turkey Company, a group of English merchants, an exclusive charter to trade with the Ottomans. British trade continued with minor interruptions for 333 years until the declaration of war in 1914. (Trade soon resumed when the Turkish republic was proclaimed in 1922.) Colonies of merchants with special privileges granted by the Sultan meant that merchants were the most frequent European visitors to the Ottoman Empire. (For an image of what a British Turkey merchant looked like, see the portrait of Mr Levett by Liotard on p.60.) Subsequently, images of Turks were used to advertise the goods they traded, particularly coffee and tobacco. Along with these goods, some of the habits of the Turks were adopted, particularly the culture of the city coffee house (as opposed to a tavern) as a place for the meeting of merchants and traders and the exchange of information. This was to have extraordinary results in the future, not least because the early coffee houses in London provided places for the ever increasing trading of stocks and shares.

Views of Cairo, the Nile and the Pyramids of Giza

*c.*1510–20
Anonymous, probably Italian
Ink, watercolour and body colour on paper with an
Italian watermark of the early 16th century
V&A: SD1237

These unusual illustrations are not by a profes-
sional artist, and therefore look very different
from most Italian drawings that survive from
this date. They might be a traveller's record of a
pilgrimage, a trading expedition or an ambassa-
dorial visit. The Venetians had long-established
trading agreements with the Mamluk Sultans
of Cairo, the rulers of Egypt from 1250. The
Venetians exported many kinds of goods; the
most valuable included oil, slaves, wool and silk
cloth, and glass (including mosque lamps). In
return, they imported mainly pepper and other
spices, which were so valuable that they almost
became a kind of currency.

The trade with Egypt was carefully regulated
by the Venetian republic, and pilgrims to the
Holy Land (which included Egypt) were also
permitted to book passages on trading ships.
In 1512 a special envoy, Domenico Trevisan,
was sent from Venice to Cairo to renegotiate
the terms of trade and to secure the release
of Italians who had incurred the Sultan's
displeasure.

Although the depictions of Alexandria,
the Nile and Cairo are rather primitive, the
buildings and monuments are recognizable and
in relatively the right place. The aqueduct that
is such a prominent feature of the view of Cairo
was restored by the Sultan al-Ghuri in 1508.

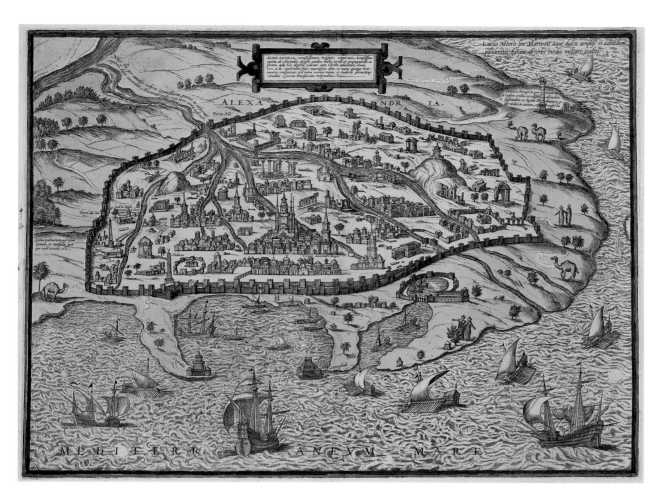

Alexandria

Plate 56 from Georg Braun and Frans
Hogenberg, *Civitates orbis terrarum de prae-*
cipuis totius universi urbibus, liber secundus …

*c.*1580
Frans Hogenberg (before 1540–*c.*1592)
Engraving coloured by hand
V&A: SP113

Early maps now look quaint, yet they met the
need for pictorial representation and information
that traders and other travellers required before
contemplating a journey. Mapmakers adopted
the technique of engraving from about 1500, but
at first they retained conventions from hand-
drawn maps. These views of cities were closer in
spirit to diagrams, giving generalized informa-
tion and emphasizing the important features
of a city, or at least those important to the
visitor, rather as some tourist maps do today.

The representation of the city has a large ele-
ment of the fanciful. Taken from the traditional
bird's-eye view, in order to include significant
features and monuments (notably Pompey's
column and Cleopatra's needles), it is set in a
picturesque landscape in which the symbolic
figures of the inhabitants (and in this case
camels) are variously placed. Numerous ships
have taken the place of the usual foreground
figures, to emphasize Alexandria's maritime
importance. The close trading links between
Egypt and Venice in the sixteenth century
might explain why the original view that
Hogenberg copied for his print was probably
made by an Italian.

Civitates orbis terrarum ('Cities of the World')
was conceived as an atlas of city plans and views
to accompany Ortelius's atlas *Theatrum orbis*
terrarum (1570). It eventually comprised six
books published in the years 1572–1618, in
many editions, mostly in Cologne. Many of the
plates were after drawings by the topographical
artist Joris (or Georg) Hoefnagel (1542–1600),
but the example here appears to have been
based on an unidentified Italian engraving,
redrawn and engraved for this publication
by Hogenberg.

Figure of a Merchant with a Crate Marked Caffee

*c.*1780
Anonymous, perhaps British School
Pen and ink and watercolour, over pencil
V&A: SD1307

This watercolour may be a design for an illustration, or some kind of trade card or even a painted sign for advertising. In the minds of early consumers, coffee was inevitably linked pictorially with its Ottoman origins. This image of the trader may be derived from a costume study of a Smyrna (modern Izmir) merchant. The crate of coffee has the merchant's mark on the side, as well as the number 100, presumably a hundredweight.

Coffee, once a local drink made from the roasted berries of plants found in Yemen, has now permeated almost the entire world. The history of its early use is shrouded in legend, but it was supposed to have been used by dervishes to help their meditations. Beans exported from Mocha on the Arabian coast arrived in Istanbul in 1543. The Sultans were not sure at first what to do about the stimulating drink (because it is not mentioned in the Qur'an) and tried to ban it for a while. They had the same difficulty with tobacco, which arrived in 1601.

Turkey merchants brought the habit of coffee drinking back to Europe, and coffee houses had opened in Oxford and London by the mid-1650s. A merchant called Pasqua Rosee from Izmir, who had seen Turkish coffee houses first hand, opened one of the first 'at the sign of his own head' near Cornhill in the City of London. Introduced by merchants, the coffee houses became fashionable places for them to meet, and provided a milieu for a new culture of business and political debate, allied with the introduction of modern banking and insurance systems. Although the early coffee houses of Britain seemed to have had plain interiors, unlike their elaborately decorated counterparts in Turkey, there were some symbolic references to their origin. The waiters sometimes wore turbans, and the painted sign outside was often that of the head of a sultan. By the nineteenth century it is alleged that up to 57 different 'Turk's Head' signs could be found on coffee houses in London.

Slippers

1804
William Marshall Craig (d. 1827)
Etching and aquatint
Guildhall Library

This print shows an Ottoman Turk selling slippers outside Somerset House in the Strand, London. It was reproduced in *Modern London*, a guidebook published in 1804 by Richard Phillips of St Paul's Churchyard, City of London. In that book the following *Description of the Plate* was offered:

SLIPPERS –
THE Turk in the annexed Plate is a portrait. Habited in the costume of his nation, he has sold Morocco Slippers in the Strand, Cheapside, and Cornhill (during the hours of Exchange) for a great number of years. To these principal streets he generally confines his walks. There are other sellers of Slippers, particularly about the Royal Exchange, who are Jews, and are very importunate for custom, while the venerable Turk uses no solicitation beyond showing his Slippers. They are sold at one shilling and sixpence and two shillings per pair, and are of all colours and sizes.

There then follows a note about Somerset House, the location of the itinerant trader in this plate. This print derives from a watercolour, one of ten by William Marshall Craig, acquired by the V&A in 1874. The group is entitled *London Street Cries* and shows various traders selling their wares on the streets of London.

The Turk was no ordinary street vendor and seems to have been an astute businessman. He was exploiting his own oriental appearance, even maintaining in the face of active competition a grave and 'venerable' demeanour, popularly thought to be the characteristic of Turkish merchants. It almost certainly was his own habit, but it seems he was not tempted to change it. However, he was actually selling expensive Morocco slippers (a type of leather, not slippers from Morocco), presumably imported from Turkey, directly to wealthy bankers and traders at two shillings a time, without the overheads normally associated with a shop. (A labourer might earn as little as one shilling a day in 1804.) Whatever reveries the customers indulged in as they finally donned their slippers and relaxed at home, perhaps while smoking, they would be reinforced by the knowledge that these Turkish accessories of comfort had been purchased from an authentic Turk.

Craig was mainly a book illustrator and an engraver, though he seems to have been able to turn his hand to anything, including designing decorations for snuff boxes and painting miniature portraits. His carefully drawn series of *London Street Cries*, showing real characters selling a fascinating and sometimes unexpected range of goods in front of London landmarks, rivals the familiar series of street cries by Francis Wheatley painted in the previous decade.

The Realm of the Imagination

After the introduction of printmaking into Europe in the fourteenth century, there was an ever-increasing demand for illustrations to supplement the imagination of the reading public. Artists made a living by sketching any aspect of the Ottoman lands or culture that was demanded or commissioned by publishers and print sellers. In many cases, however, there was no desire for topographical accuracy or minute observation, since the public seemed content with images that conformed to the picturesque world they had already formed in their imaginations. Illustrators (many of whom never left Europe) provided the curious public with the images they desired, and not what a modern scientific detached observer would now want them to have. To do them justice, they did provide relatively straightforward reporting of events or depiction of scenes to supplement the texts when required.

In some contexts the imagination simply had to be indulged, because there was no other way. For example, no one in the early nineteenth century really knew what the Holy Land and its inhabitants had looked like in the time of Christ and before, so the modern landscape of Palestine and Egypt and the pre-industrial society of the Ottoman subjects there had to be transmuted and substituted for the patriarchal lifestyle of the Old Testament. Illustrations of the lands of the Bible, the 'Landscape of Belief', were very popular with churchgoers in the nineteenth century, even though much of this landscape was mythical.

There was also a demand for the realms of a very different fantasy, as in the long-lived European idea of the 'odalisque' in the imaginary harem. As in Victorian Britain, the intimate details of family life were taboo and never discussed with strangers, so the family life of ordinary Ottomans was equally mysterious, or more so, to outsiders. Occasionally, grotesque fantasies about the Sultan were built up on this ignorance, and some illustrators were happy to oblige their public with erotic images. The 'odalisque' theme finally expired in the twentieth century, having lost all connection with any kind of reality.

A Mamluk from Aleppo

*c.*1810–23
William Page (1794–1872)
Watercolour over pencil
V&A: SD724

The Mamluks (literally 'owned', i.e., slaves) had
controlled Egypt from 1250 until the Ottoman
conquest of 1516–17, yet even then they still
continued to govern Egypt for the Ottoman
Sultan, while paying tribute. Originally, they
had been a military caste of former slaves serv-
ing the Egyptian sultans. Young boys, mainly
Kipchak Turks from regions north of the Black
Sea, had been bought from slave dealers and
trained as warriors by previous generations of
Mamluk amirs or commanders. They were set
free on reaching adulthood, given a horse and
arms, and then took employment with their
former masters. In 1250 a group of Mamluk
generals seized power from the Ayyubid
dynasty, and ruled Egypt, even after the
Ottoman conquest, until the time of Napoleon's
invasion in 1798. Under the Mamluk Sultan
Baybars, in 1260 they had even defeated the
Mongols in a pitched battle. Although to the
end spectacularly brave horsemen, their power
slowly declined. The Egyptian economy was
weakened by the rise of European trading rivals
and new trade routes, and by devastating
visitations of the plague. After surviving the
invasion by the French, and then the British,
the Mamluks struggled on. Yet, apart from a
few survivors, the most prominent were finally
eliminated in 1811 in a treacherous massacre by
the new ruler of Egypt, the Albanian general
Muhammad Ali.

This is one of 21 costume figure studies, prob-
ably intended for illustration, by Page in the
Museum's collections. They show Ottoman
subjects of various ranks and occupations, both
male and female. Page recorded in fine detail
their elaborate costumes in the last years
preceding the modernizing reforms that steadily
eroded many traditional forms of dress and
behaviour. It is not clear how many Mamluks
survived the massacre by Muhammad Ali in
1811, but the detail of the costume of this indi-
vidual, and that it seems to be a kind of portrait,
implies that Page saw this survivor first-hand.
Unlike Alken's preoccupation with horses (see
opposite), Page has focused his attention on the
remarkable costume, including the embroidered

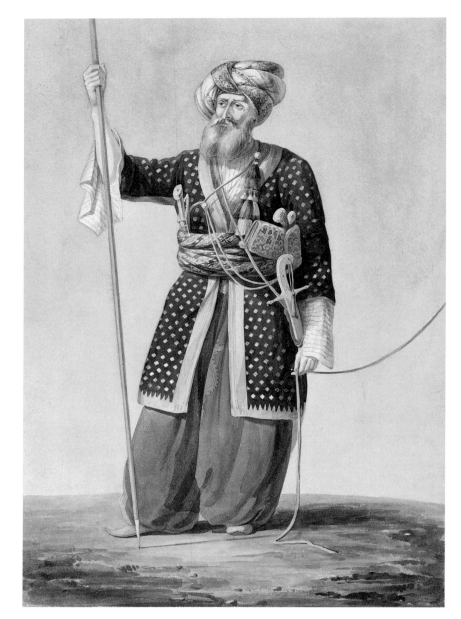

shawl round the waist and the distinctive turban.
The only thing to suggest he was a horseman is
the rope he is holding, and the long lance that
had made the Mamluks so feared in battle.

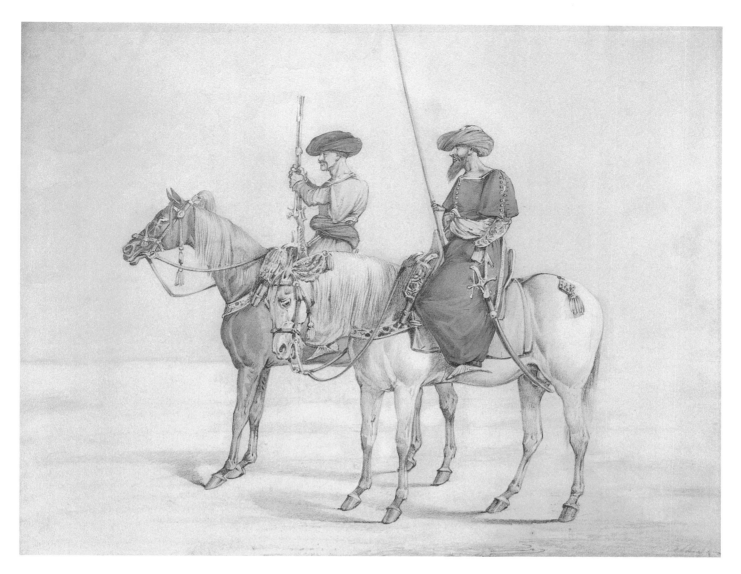

Two Mamluks on Horseback

*c.*1827
Henry Thomas Alken (1785–1851)
Pencil and watercolour
V&A: SD17

Henry Alken had probably never seen a Mamluk, yet this did not matter to his customers. What they wanted was an attractive illustration of renowned warrior horsemen and their noble animals. It is difficult to understand now, in the age of the internal combustion engine, the sheer pervasiveness of nineteenth-century hippomania. Sporting-print shops were common, their stock largely consisting of all manner of horse portraits, pictures of jockeys, famous horsemen, hunters, in fact anything to do with horses at all. Alken was an artist and printmaker who first published his prints under the pseudonym 'Ben Tally Ho!' and went on to become perhaps the best-known maker of sporting prints. Portraits of horses and horsemen were more valued than other more conventional portraits. For example, a coloured engraving after a portrait by Sir Thomas Lawrence sold for about £2; a set of eight sporting prints after Alken by the same printmaker cost £50, an enormous sum in the nineteenth century.

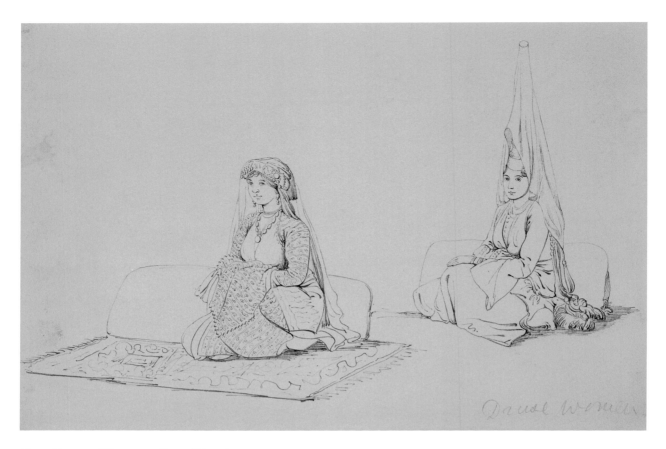

Two Druze Women, One Wearing a Tantour

1820–30
Anonymous, British School
Pen and brown ink
V&A: SD1309

The strange headdresses of some Lebanese women attracted the curiosity of many travellers. R.R. Madden wrote of them in 1829:

> The women wear a horn projecting from their foreheads, called tantoor, twenty inches long and tinselled over with gold and silver leaf, and sometimes with tin-foil. I saw one on the head of a young married woman near Deir el Kammar of solid silver. I endeavoured to prevail on her to sell me another which she showed me, of solid brass: but she said she would rather part with her head than her horn: it illustrates the scriptural expression 'thine [sic] horn has been exalted' [1 Samuel 2:1] and it is undoubtedly a very ancient custom.

Although it had nearly disappeared by the mid-nineteenth century, the *tantour* had a long tradition of being worn by wealthy Druze and Maronite women, and a bride would wear it as a sign of her married status. Young girls wore them rarely, and then only if they were of noble birth. A husband customarily presented the *tantour* to his bride on their wedding day. Scholars have tried to explain their origin, and comparisons have been made with similar bizarre tall headdresses, the *Hennins*, worn in France by Burgundian noblewomen in the 1460s. Some other commentators even suggest a Mongolian origin, but the lack of documentation makes their origin uncertain.

This fine pen-and-ink drawing is by an accomplished artist, probably a British book-illustrator of the 1820s, whose identity is still as mysterious as the *tantour* itself. The image may have been intended as an illustration in a book of picturesque costume.

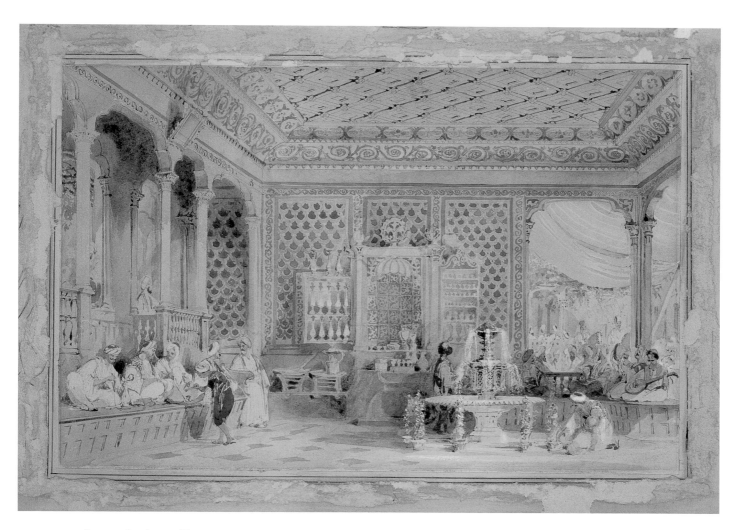

Interior of a Turkish Caffinet, Constantinople

1838
Thomas Allom FRIBA (1804–1872)
Watercolour over pencil
V&A: SD19

This watercolour was reproduced as an etching to illustrate the Revd Robert Walsh's *Constantinople and the Scenery of the Seven Churches of Asia Minor,* published in 1838. According to Walsh's text accompanying this picture, 'the caffinet, or coffee-house is something more splendid, and the Turk expends all his notions of finery and elegance on this his favourite place of indulgence' (p.59). This coffee house is typical of the ornate Rococo style in which many of them were built. They were timber-framed, the interiors carved and painted, and often equipped with small decorative fountains to cool the air in summer. Here the customers could drink their coffee while listening to music, have a shave, smoke their pipes, listen to story-tellers, meet their friends or just relax. Since these structures were made of wood, they were particularly vulnerable to the terrible fires that broke out frequently in Istanbul. It is doubtful if a single example of a Rococo wooden coffee house from the nineteenth century survives.

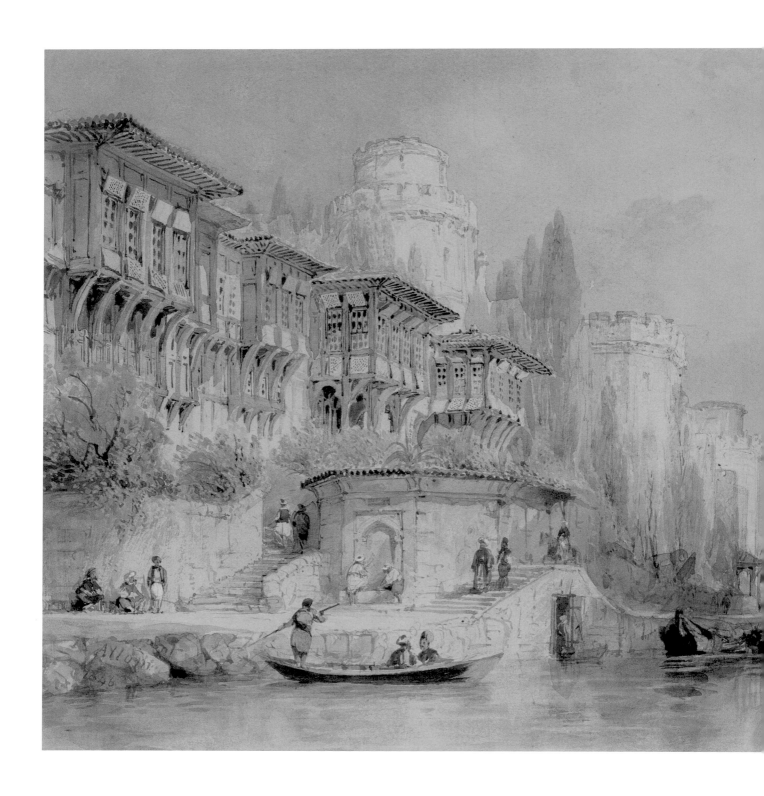

Summer Houses and the Castle of Europe on the Bosphorus

1846
Thomas Allom FRIBA (1804–1872)
Watercolour over pencil
V&A: SD20

Many artists drew and painted the historic shores of the Bosphorus, the deep and narrow channel between Europe and Asia. A favourite subject was the romantic mediaeval fortress of Rumeli Hisarı ('Castle of Europe'), built by Mehmet II in a few months before he conquered Constantinople in 1453. It dominates the narrowest part of the straits, opposite its counterpart on the Asia shore, Anadolu Hisarı, seen in the distance in Allom's view. Allom has made a picturesque juxtaposition of the stone crenellations of the castle with the fretted wooden balconies of the houses or *yalı*, which 150 years ago were a distinctive feature of the villages along the Bosphorus.

Although he trained as an architect, Allom is now better known as a topographical artist. In 1834 he was a founder member of the Institute of British Architects (later the RIBA), of which he became a fellow in 1860. He first drew views to finance himself as a student, but was so successful that he then travelled widely and contributed at least 1,500 illustrations to numerous books on places in Europe, the Near East and even China, published during the 1830s and '40s. Few details of his journeys are known, but between 1828 and 1845 he made extensive sketching tours in England, Scotland, France, Belgium and Turkey, mainly for the publisher H. Fisher & Son.

Allom obviously delighted in the picturesque details of the Turkish wooden houses, but did not incorporate these ideas into his own architecture. He designed a number of buildings in a wide variety of traditional styles, including workhouses in the Jacobethan manner and neo-Gothic churches, as well as Italianate houses on the Kensington Park Estate in the 1850s.

The Emperor of Austria Ascending the Great Pyramid

1869
William Simpson RI FRGS (1823–1899)
Pencil and watercolour
V&A: SD970

This scene was described in the *Illustrated London News* in December 1869, and Simpson, who had an eye for the absurd, wrote in his *Autobiography*: 'I went out one day and saw the Emperor of Austria lugged to the top of the Great Pyramid by two Arabs as if he had been only an overland passenger.' Then, as until recently, the energetic local inhabitants unceremoniously hauled many visitors to the top of the monument, helping the unfit and overweight to clamber up the huge blocks. Emperor Franz Joseph was one of many European dignitaries in Egypt in November 1869 for the opening of the Suez Canal. The canal replaced the tedious and sometimes difficult 'Overland Route' via Cairo and across the desert on the way to India.

Simpson was a lithographer and prolific watercolour painter, who eventually became what would now be called a war correspondent. He was sent by Colnaghi's, the print publishers, to cover the Crimean War in 1854–5, providing drawings for lithographs published in *The Seat of War in the East* (1855–6). From 1866 he was employed by the *Illustrated London News* as their 'Special Artist' to report on and illustrate many of the wars and grand ceremonial occasions of the British Empire and elsewhere. Simpson's vigorous sketches were swiftly transformed into wood-engravings, giving the ever expanding pool of news-hungry readers the illustrations they craved. He lived long enough to see photography start to replace his form of reportage in magazines.

Heliopolis, – As it is

1878
William Simpson RI FRGS (1823–1899)
Pencil, watercolour and body colour
V&A: SD971

Simpson was not usually critical of his fellow
Britons; ultimately they employed him to illus-
trate their empire and world events. However, he
was capable of seeing and recording poor behav-
iour by the ever-increasing hordes of British
tourists. Here they are shown galloping on their
donkeys, oblivious of the Obelisk of Senusert at
Al-Matariyyah (Heliopolis). What makes this
worse is that the Egyptian hoteliers specifically
requested that the often beefy visitors should
not 'gallop the donkeys', which were not
designed for it. Alas, the thrill of racing has con-
sumed the thoughtless riders, as they rush past
the antiquities they had ostensibly come to see.

Sardis

c.1830–35
Possibly by a Mr Maude (active c.1830–36)
Brown wash over pencil
V&A: SD639

Sardis. One of the Seven Churches

1834–5
Clarkson Frederick (later Thomas Clarkson) Stanfield RA
(1793–1867)
Watercolour and body colour over pencil
V&A: SD1000

Sardis. One of the Seven Churches
Plate 45 from the Revd Thomas Hartwell Horne
BD, *Landscape Illustrations of the Bible*, 2 vols,
London: John Murray, 1836

William Finden after Clarkson Stanfield
Etching
V&A: SP259.42

This sequence of images is worth examining in some detail for the light they cast on Victorian book illustration generally, as well as the particular desire for biblical illustration and the 'landscape of belief'. Everyone literate then knew their Bible, and many were curious about the places mentioned in the scriptures. The market was such that, in the period between 1800 and 1878, no fewer than 2,000 authors were to publish books on Palestine.

In 1832–3 the publisher John Murray commissioned Sir Augustus Wall Callcott, William Turner, David Roberts, Clarkson Stanfield and James Duffield Harding, and other established artists, to provide drawings for a series of prints illustrating biblical scenery, finally published as *Landscape Illustrations of the Bible*. Some drawings were imaginary, yet this real on-the-spot sketch by a 'Mr Maude' (otherwise unknown) was used in the case of Sardis. It is a rather dull but competent amateur ink and wash sketch of the only two columns still standing of the Temple of Artemis, with no figures or anything of emotional interest. Sardis, now the flourishing town of Sart in modern Turkey, was a desolate spot in the 1830s. Then the visitor saw only a few ruins, a pathetic remnant of the fabulous wealth of one of the Seven Churches of Asia to which the Apocalypse, the Revelation of St John the Divine, had prophesied utter destruction.

William Finden, the engraver, then gave Clarkson Stanfield this unprepossessing drawing to 'work up' and do his best with. Why Finden did this is obvious. Stanfield duly used it as the starting point for his own painting, yet immediately made it into a dramatic watercolour, rivalling his contemporary, the painter John Martin, by introducing a thunderstorm and a rider who has been thrown down by his horse, panicked by the apocalyptic weather. The finished print in the book is a fairly faithful version of this dramatic improvement. Stanfield was well qualified for this dramatization. With David Roberts, he was one of the principal theatrical scene painters of his day, as well as a marine painter rivalling Turner. Remember, it was not merely a picture of some ruins; the image referred to the fulfilment of a biblical prophecy, which actually looked forward to the final days, the terrible moment of God's Last Judgement. Only an artist's imagination could transform Mr Maude's record drawing into a visual sermon.

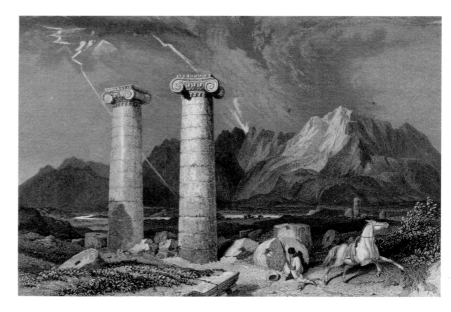

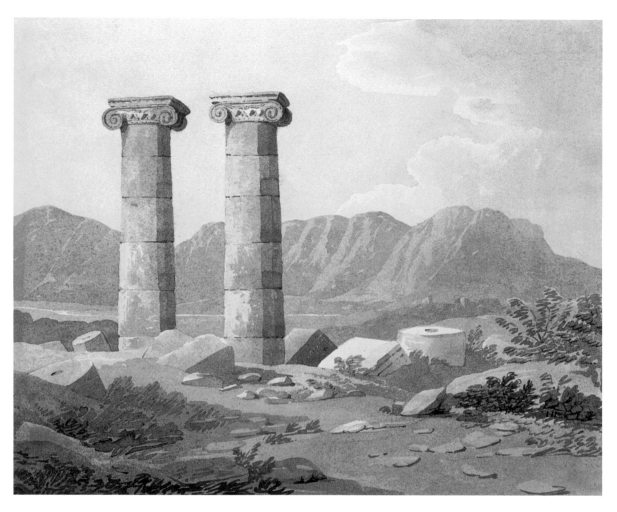

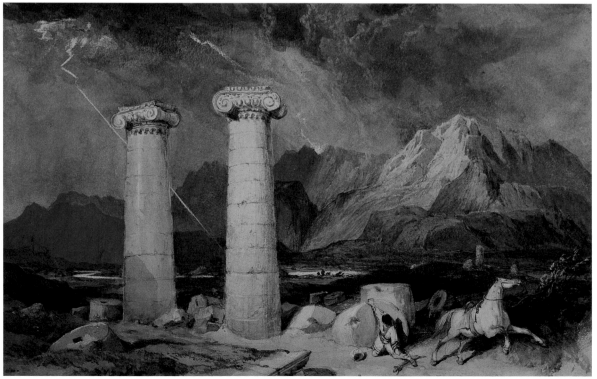

Part of the Hall of Columns at Karnak
Plate from *The Holy Land . . .*

1842–9
Louis Haghe after David Roberts (1796–1864)
Lithograph, coloured by hand
V&A: L.664:13–1920

This print is from the most ambitious lithographic work ever published in England: David Roberts's *The Holy Land, Syria, Idumea, Arabia, Egypt & Nubia* (1842–9). It was issued in parts, but is now often found in a set of six folio volumes consisting of 248 lithographs with descriptive text. Roberts praised the lithographer Louis Haghe for the faithful and artistic interpretation of his drawings, and he shares the credit for the great success of this publication. It was published by subscription, which rapidly amounted to a total of more than £20,000, a gigantic sum at 1840s prices. Since these lithographs were printed with a series of tint stones with additional hand-colouring, a number of assistants helped Haghe to prepare the total of more than 600 stones.

Roberts was already established as a successful painter before he achieved a long-held ambition to visit and paint the lands of the Bible. He had assumed that there would be a good market for picturesque images of the Holy Land among the large number of churchgoers in Britain, and he was proved right. In 1838 he set out for the East. In Cairo, Roberts hired a *kanja* or Nile boat, and sailed up the Nile as far as Abu Simbel, stopping on his return north to sketch temples and ancient sites such as Philae, Karnak, Luxor and Dendera. His early work as a theatrical scene painter enabled him to choose the best viewpoint and subtly exaggerate the proportions and the panoramic vistas of the massive structures he found. In his drawings, he even restored to some extent the original colouring of the sculpture, of which there were still substantial traces visible in the nineteenth century.

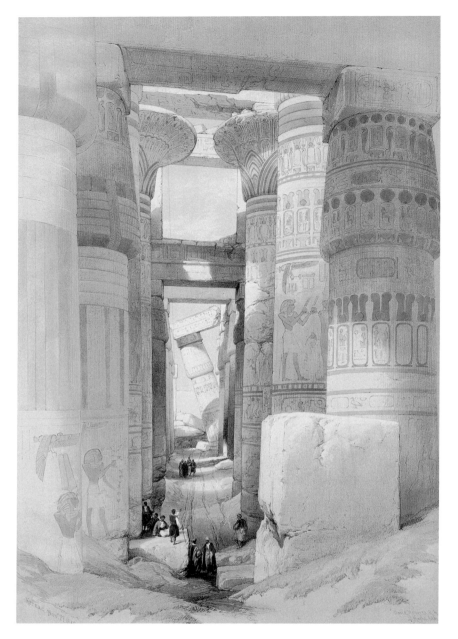

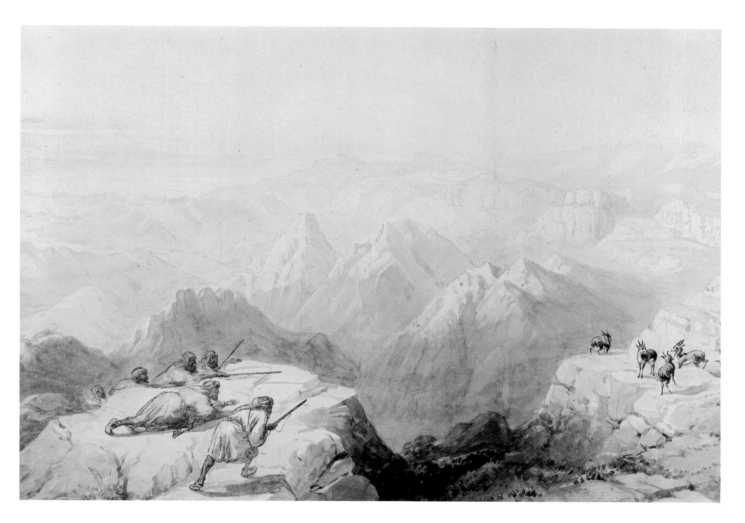

View from Mount Hor [near Petra]

1845–8
William Henry Bartlett (1809–1854)
Pencil, ink, watercolour and body colour
V&A: SD83

Bartlett was a prolific topographical artist who travelled extensively in search of new and interesting subjects for his drawings. He visited North Africa and the Near East seven times, and made several other trips in Britain and continental Europe, as well as North America. Popular demand for travel books was high in the 1830s and '40s and Bartlett contributed illustrations to several of them. After 1842 he wrote and illustrated about a dozen of his own travel books. His self-confessed purpose as one of 'a flying corps of light armed skirmishers, who, going lightly over the ground, busy themselves chiefly with its picturesque aspect', was to give 'lively impressions of actual sights'. This quotation comes from his book *The Nile Boat* of 1850, and sums up the philosophy of many artist illustra-

tors of that period. They and their public were romantic in outlook, not yet interested in serious quasi-photographic accuracy. They preferred colourful and picturesque views, based on some kind of reality, but an impressionistic one.

This scene is set on the biblical Mount Hor, now Jabal Harun (Mount Aaron) in Jordan, where the Prophet Aaron, brother of Moses, died and was buried before he could enter the Promised Land (Numbers 20:28). When Bartlett drew this, the story was familiar to the Victorian Bible-reading public and no explanation would have been needed. The hunters are stalking wild goats, probably ibex, still to be found in Jordan. Again, with the Victorian obsession with hunting, this scene was a familiar theme set in unfamiliar surroundings.

The Cedars of Lebanon

1858
Edward Lear (1812–1888)
Pencil, brown ink and watercolour
V&A: P.4–1930

The image of the Cedars of Lebanon was central to ancient Hebrew poetry. It occurs in many verses in the Bible as a synonym for physical beauty and, at other times, the glory of the Lord and all created things. These poetic passages, translated into the vivid language of the Authorized Version (the King James Bible), published in 1611, became poetic and memorable in the minds of English churchgoers as well. The cedars impressed Lear above all else in Lebanon, since the combination in them of natural beauty and the evocation of the Bible was one that was deeply sympathetic to his sentiments. He climbed up to 6,000 feet on the mountain at Besharri, and despite the bitter cold, made at least two fine drawings, of which this is one.

Lear had begun as an ornithological draughtsman, being particularly noted for his sensitive natural history drawings of the parrot family. He went on to become a traveller and a prolific landscape painter in watercolour, and, of course, a famous writer of nonsense rhymes and stories.

He made extensive travels to Europe, the Near East and India, which included five visits to Egypt and the Holy Land, between 1849 and 1872, publishing and illustrating his own travel accounts. His ambition was to establish his reputation as an oil painter, and he painted at least four versions of the cedars in oil. The first, very large in format, was painted in the winter of 1860–61 with the aid of some ancient cedars in the grounds of the Oatlands Park Hotel in Surrey. (In Lear's defence, since cedars are not native to Britain, and because of their biblical associations, they probably were descended from seed brought back from the Holy Land.) It did not sell, however, and his main source of income remained the hundreds of distinctive watercolours he produced, now dispersed into public and private collections throughout the world.

Trompettes, Pages, Esclaves, et Vases, que l'on portoit pour present, à Mahomet

Plate from a set of 32 from J. Vien, *Caravanne du Sultan à la Mecque*, Paris

[1748]
Joseph Marie Vien (1716–1809)
Etching
V&A: SP628

This is the frontispiece to Vien's set of etchings *Caravanne du Sultan à la Mecque*, which commemorated the masquerade staged by the students of the Académie Française for the annual carnival in Rome in 1748. This fantasy was initially inspired by accounts of the annual pilgrimage to Mecca, and the caravan of gifts sent by the Ottoman Sultan. In fact, it was an opportunity for designing (and dressing up in) brilliantly coloured costumes, and making ingenious stage properties and a carriage for the cavalcade. The French ambassador wrote:

> More than forty different costumes were exhibited, representing every Eastern country as well as the principal personages at the Court of the Grand Seigneur [the Sultan]. About twenty of them were on horseback, the rest in a carriage which they had transformed into a magnificent wagon in shape and dimensions. Their clothes, though only linen, were so well painted that even from close up they could have hardly resembled more exactly the real materials and brocades. You cannot really imagine the applause that greeted this cavalcade (which is very much to the taste of this part of the world), as it passed along the Corso, alike from the people and from the nobility.

The masquerade was a manifestation of the 'turkomania' that gripped Europe in the mid-eighteenth century. Ultimately, this mostly consisted of dressing up in Ottoman-style costume, sometimes even authentic. Obviously Vien, a gifted student of painting and design who had known only France and Italy, had never witnessed, and therefore misunderstood, the significance of the *Mahmal* or richly caparisoned camel sent by the Sultan to lead the pilgrimage to Mecca every year. Indeed, the kinds of gifts that Vien fondly imagined include a rather interesting set of Neo-classical vases, which he seems

Trompettes, Pages, Esclaves, et Vases, que l'on portoit pour present, à Mahomet.
Jos.Vien inv. Sc.

to have designed himself. His fantasies prefigure the kind of vases that were actually being made in Rome (but definitely not in Istanbul) some twenty years later. This suite of prints was therefore also a kind of self-advertisement. On the evidence of this image, Vien knew little of Ottoman costume. He and his colleagues must have been very skilled artists to make painted linen look like silk in bright sunlight and to ensure their theatrical effect met with great applause.

A Sultana

1777
Philippe Jacques de Loutherbourg RA (1740–1812)
Etching and stipple, printed in red
V&A: SP194

This fantasy image of a Sultan's consort was deliberately designed to appeal to those who wanted a mildly erotic picture for a boudoir or bedroom; like many so-called fancy pictures, its function was purely decorative. However, Loutherbourg took the trouble to get some of the details correct, at least as far as the ethos of the print was concerned. For example, the lady is offering her parrot sugar or a sweetmeat, a frequent image in Indian and Iranian love poetry. The costume is not far removed from Ottoman fashions of the day, and the room of the lovelorn Sultana is provided (as it should be) with a perfume burner (to the left of the table), although the table itself seems to be completely inauthentic in design. Any failings in the print's imagery did not disqualify it from being used as the source for an early nineteenth-century Mughal painting by an unknown artist, probably from Lucknow (Chester Beatty Library, Dublin).

Loutherbourg came to London from Paris in 1771. He was an immensely versatile artist. Many of his paintings dealt with dramatic events, such as battles, shipwrecks, storms, fires and avalanches, but he also depicted calmer subjects, such as pastoral scenes and landscapes. He was an occultist and an inventor, and for a time set up in London with his wife as a kind of spiritual healer. His involvement in the theatre was considerable, particularly as a stage designer and innovator in stage effects. He was active as a printmaker and experimented with a variety of techniques. Here his drawing has been rendered, with the soft effects of etching and stipple, by the Russian printmaker Scorodomoff (or Skorodumov) from St Petersburg, who was in London during the years 1775–82.

A SULTANA.
— O let me press thee.
Pant on thy Bosom...sink into thy Arms.
And lose myself in the Luxurious folds.
LONDON. Printed for R. SAYER & J. BENNETT, Map & Printsellers, No. 53 Fleet Street, as the Act directs 8th Octr 1777.

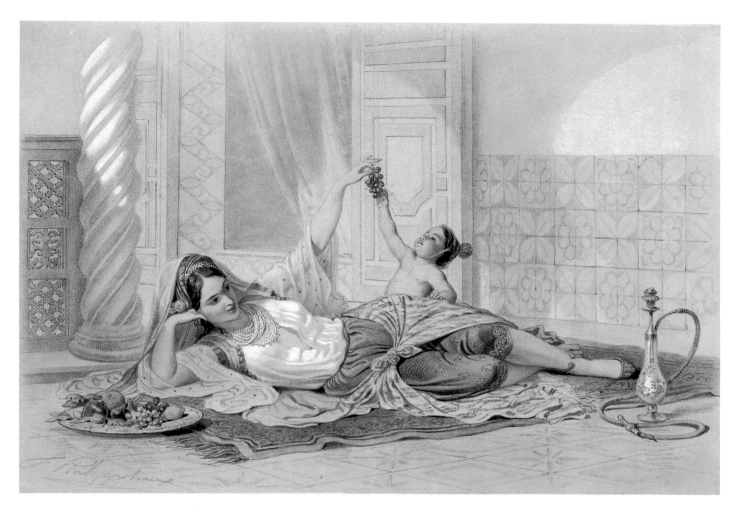

An Odalisque Playing with a Child

*c.*1843
Henri Félix Emmanuel Philippoteaux (1815–1884)
Pencil and watercolour
V&A: SD801

This is a rare example from our collections of an image of an 'odalisque'. The term is a French mishearing of the Turkish word *odalık*, or domestic slave. Prurient curiosity (tinged with male envy) about the domestic arrangements of Muslims seems to have given rise to a large genre of fantasy pictures made to satisfy Europeans as to what eastern women looked like, or in fact how European males imagined they might look. They, of course, range from the mildly titillating (as here) to the outright porno-graphic, the pictorial equivalent of the infamous early nineteenth-century novel *The Lustful Turk* (1828). Compare the 'Croix-Mesnil' photograph (p.124) and the lithograph of Matisse (p.125) to see the long-lived nature of this fantasy theme.

Philippoteaux was mainly a skilful painter of military subjects and portraits, a panorama painter and also an engraver and illustrator. The Duke of Wellington owned one of his paintings of the Battle of Waterloo. The artist had provided illustrations for a book about Algeria, and this may have influenced him to produce images similar to the one shown here.

'A Sleeping Odalisque', study for the painting Odalisque with a Slave

*c.*1835
Jean-Auguste-Dominique Ingres (1780–1867)
Oil on canvas
V&A: CAI.57
Ionides Bequest

Ingres, a superb draughtsman, painted portraits and historical, mythological, allegorical and religious subjects. He also pioneered a new treatment of the nude, with his painting the *Grande Odalisque* of 1814, one of the greatest figure studies of the nineteenth century, now in the Louvre in Paris. He returned to this theme many times, and the V&A's oil is thought to be a nude study for his partially draped *Odalisque with a Slave* of 1839. There are various related drawings of sleeping odalisques for this oil in the Musée Ingres at Montauban, his birthplace. Ingres is alleged to have been influenced in depicting oriental nudes by reading Lady Mary

Wortley Montagu's famous eyewitness account of women bathing in the *hamam* in Sofia in Ottoman Bulgaria. Her account is much more aesthetic than sensual in tone, but Ingres, like many male artists who subsequently imitated his example, emphasized the erotic nature of his imagined scenario.

This painting, with many others, was bequeathed in 1901 to the Museum by Constantine Alexander Ionides. He had built up a major collection of European painting, and Ingres's treatment of the odalisque theme is unique in the Museum's collection of oil paintings.

Odalisque with a Slave

1839
Jean-Auguste-Dominique Ingres (1780–1867)
Oil on canvas
Fogg Art Museum, Cambridge, Massachusetts

Life in the Hareem, Cairo
[An Inmate of the Hareem, Cairo]

1858
John Frederick Lewis (1804–1876)
Watercolour and body colour
V&A: 679–1893

At first sight, *Life in the Hareem, Cairo* is another decorative picture with no obvious story. Yet the posy of flowers held in the lap of the main figure is in fact a love letter, in the language of flowers, used in Turkey and Egypt as well as Britain. This was a favourite theme in Lewis's work. The whole scene could be interpreted as showing a woman about to take coffee with her confidante, to discuss the newly arrived love letter and its implicit offer. Then they will read the future in the coffee grounds in the traditional manner (still practised in Cairo) to see how the affair may turn out. Lewis painted various versions of this theme.

Lewis had arrived in Egypt in 1841 and lived for nearly a decade as a wealthy Turk in a grand sixteenth-century house in Cairo. He was obliged to do this, as were other European residents, since at the time his neighbours would not have tolerated alien dress and customs in that particular district of the city. In 1847 he married the much younger Marian Harper, who appears as a model in many of his pictures, including this one. In Cairo he lived with his bride like a Turkish Bey, or grandee, in everything except (as far as we know) the actual practice of the faith of Islam, so the decorous pictures of Marian in her robes in that splendid house are not really fantasies at all. The house certainly existed (its distinctive details were sketched by other artists); the costumes are real, and were worn. Marian lived in the *haram*, the private section of the house where only women and certain relatives were admitted by her invitation.

This painting once belonged to the art critic John Ruskin, who passionately admired the amazing technique that made Lewis perhaps the most skilled practitioner of watercolour painting in Britain at the time. Yet he went on to complain about the lack of narrative in some of Lewis's later paintings. In fact, the exquisite finish, the ambiguity of the narrative and the intimate nature of these interiors made Lewis the British equivalent of Vermeer, and not just a decorative painter of Orientalist themes.

Portrait of a Woman in Eastern Dress

*c.*1890
Anonymous, Belgian. From the portfolio *Femmes
d'orient*, Brussels, 1893
Gelatin-silver print
V&A: Ph.3794–1904

This photograph is typical of a whole genre of
studio-posed studies of women in eastern dress.
A woman is shown in some indeterminate cos-
tume that may or may not be partly real, posed
against a studio backcloth that is not even east-
ern in style. The coin headdress suggests some-
where in North Africa, but the sofa and the
other props are European. No matter where it
was taken, it reads only as an attractive woman
in fancy dress. This image is part of a portfolio of
diverse photographs of alluring women in quasi-
eastern costume, some of them in even more
ludicrous studio settings. They are apparently
by various unnamed commercial photographers
and gathered together opportunistically by the
portfolio's Belgian publisher under the title of
Femmes d'orient. It even has a short title-page

essay by the 'Comtesse de Croix-Mesnil' that
justifies Muslim polygamy and condemns
Christian monogamy, and even Christianity
itself. Finally, it regrets that the Muslims were
unable to advance further north than Spain, thus
failing to spread polygamy to northern Europe
(and presumably, unfortunately, not to France
and Belgium in particular).

Although the sentiments might be deeply felt,
the context shows that this text is probably
bogus – written or plagiarized by the publisher,
or whoever was sheltering under the pseudonym
of the 'Comtesse de Croix-Mesnil'. The real pur-
pose of this portfolio was to appeal to sensualists
with anti-clerical tendencies, who preferred an
imagined Orient in photographs to the realities
of bourgeois Christian Brussels.

Grande odalisque à la culotte bayadère

1925
Henri Matisse (1869–1954)
Lithograph
V&A: E.311–1935

At the beginning of the twentieth century the role of the 'odalisque', and even the word, was obsolete in its strict original sense. It had become only a confused idea in the minds of most Europeans, and the word was applied indiscriminately to any sexually attractive or alluring woman. Matisse produced a frankly erotic series of paintings and prints from 1917 of 'odalisques' that do not even pretend to any kind of ethnographic authenticity. In this lithograph of 1925 he depicts a favourite French model, Henriette Darricarrère, seated in a floral-patterned armchair, wearing only a pair of striped pantaloons (*culotte*; for *bayadère*, see p.49). She has only the flimsiest connection, a word in the title only, with any real odalisque in the past. The picture is the product of an artist's imagination, knowingly using the long-established western theme of the imagined harem to evoke an image of sensual delight. Matisse's lack of hypocrisy and his superb technique contrast with the tawdry photographs posing as a kind of ethnography (see the Croix-Mesnil photograph opposite). Yet some still find his direct eroticism offensive, especially in the context of western assumptions about the delights of the harem.

Although Matisse had visited Algeria in 1907 and Morocco in 1912–13, he is alleged to have had difficulty finding models. He did make some drawings and paintings in Morocco of 'Zorah', a Jewish woman, said to have become a prostitute, but she is shown modestly clothed and there is nothing of the 'odalisque' theme about the paintings that contain her image. Here in this print of Henriette, Matisse's 'Orientalism' seems to have been fired purely by his imagination and memories of artists such as Ingres.

Further Reading

Abbey, J.R. *Travel in Aquatint and Lithography, 1770–1860. From the Library of J.R. Abbey: A Bibliographical Catalogue*, 2 vols (London, 1956)

Atil, E., C. Newton and S. Searight. *Voyages and Visions: Nineteenth-Century European Images of the Middle East from the Victoria and Albert Museum* (Washington, DC, 1995)

Benjamin, R. *Orientalism: Delacroix to Klee* (Sydney, 1997)

Boppe, A. *Les Peintres du Bosphore au dix-huitième siècle* (Paris, 1911; revised and illustrated edition by C. Boppe, Paris, 1989)

Clayton, P. *The Rediscovery of Ancient Egypt: Artists and Travellers in the 19th Century* (London, 1982)

Darby, M. *The Islamic Perspective: An Aspect of British Architecture and Design in the 19th Century* (London, 1983)

Finkel, C. *Osman's Dream: The Story of the Ottoman Empire, 1300–1923* (London, 2005)

Imber, C. *The Ottoman Empire, 1300–1650: The Structure of Power* (London, 2002)

Irwin, R. *For Lust of Knowing: The Orientalists and Their Enemies* (London, 2006)

İşik, F. *Sultan Abdülmecid dönem'inde (1839–1861) Osmanlı imperatorluğ'na gelen ingiliz ressamlar: Victoria & Albert Müzesi Searight Koleksiyonu* (Ankara, 2004)

Juler, C. *Les Orientalistes de l'école italienne* (Paris, 1987)

Lane, E.W. *An Account of the Manners and Customs of the Modern Egyptians* (London, 1836)

Lewis, R. *Everyday Life in Ottoman Turkey* (London, 1971)

Llewellyn, B. *The Orient Observed: Images of the Middle East from the Searight Collection* (London, 1989)

—, and C. Newton. *The People and Places of Constantinople* (London, 1985)

MacKenzie, J. *Orientalism: History, Theory and the Arts* (Manchester, 1995)

Mansel, P. *Constantinople: City of the World's Desire, 1453–1924* (London, 1995)

Murphy, D., and C. Pick. *Embassy to Constantinople: The Travels of Lady Mary Wortley Montagu* (London, 1988)

St Clair, A.N. *The Image of the Turk in Europe* (New York, 1973)

Searight, S. *The British in the Middle East* (revised edition, London, 1979)

Sievernich, G., and H. Budde, eds. *Europa und der Orient, 800–1900* (Berlin, 1989)

Sweetman, J. *The Oriental Obsession: Islamic Inspiration in British and American Art and Architecture, 1500–1920* (Cambridge, 1987)

Thompson, J. *The East: Imagined, Experienced, Remembered* (Dublin, 1988)

Thornton, L. *The Orientalists: Painter-Travellers, 1828–1908* (Paris, 1983)

Wheatcroft, A. *The Ottomans* (London, 1993)

Index

Figures in *italics* refer to illustrations